Imaginative Art
Lessons for Kids
And Their Teachers

Also by the Author

PASTE, PENCILS, SCISSORS AND CRAYONS,
West Nyack: Parker Publishing Company, 1979.

Imaginative Art Lessons for Kids And Their Teachers

by

Gene Baer

Parker Publishing Company, Inc.
West Nyack, New York

Library of Congress Cataloging in Publication Data

Baer, Gene,
 Imaginative art lessons for kids and their
teachers.
 Includes index.
 1. Art—Study and teaching (Elementary)—
United States. 2. Activity programs in education
—United States. I. Title.
N362.B33 372.5'044 81-18764
ISBN 0-13-451351-7 AACR2

TO KAY WITH LOVE

Art Lessons for Fun and Learning

Nothing great was ever achieved without enthusiasm.

—Emerson

If art can be made fun and fun can be made art, then teaching can be fun, too; for if there is anything a kid likes to do it's have a good time.

Entertaining art lessons are not easy to come by, but if we put too much emphasis on classroom fun and too little on learning, we run a very real risk of playing godfather to anarchy and eyewitness to a massive waste of expensive art materials.

If, on the other hand, we confuse straightforward presentations of subject matter with *fun,* we may run the counter risk of confronting our kids with a series of well-intended, well-planned, highly structured fiascoes. There has to be a better way—and there is!

The key to a great deal of good teaching lies in the art of inspired compromise—of making lessons fun—for it is this kind of climate that gives rise to celebrated teachers, memorable art lessons, and warm and happy classrooms.

Make your lessons fun, but also make them learning experiences. Give your kids a wide range of creative possibilities, but give them lessons that teach something challenging, something different, something that will open their minds to new concepts, ideas, and horizons.

Holidays are always times for fun and festivities, and for this reason holidays make perfect launching pads from which to introduce all kinds of mind-expanding ideas. So whenever the need arises, hitch your lessons to a holiday!

When no holidays are available, do what I often do: *invent* one. I generally couple my holidays to imagined Presidential proclamations:

> "Why are we painting rocks?"
> "You mean you didn't listen to the President's speech last night? It's National Rock Painting Day!"

Since no kids and few adults ever listen to Presidential speeches, you can easily invent the most outrageous holidays to fill up the missing dates on your classroom calendar!

Another good way to inject a measure of humor into an art lesson is to actually sit down and work along with the kids. No matter how good or how bad an "artist" you are, the unprovoked admonishment, "Don't you laugh at *my* picture!" if delivered in your best mock-serious tone of voice, can always be counted upon to ignite a burst of loud and mischievous laughter.

Remarks like the one above do more than add humor; they serve to relieve the anxieties of those children who really *are* afraid of having their art work ridiculed. It has always been my experience that good, clean-hearted laughter can mend almost anything!

And always remember that whether you consider yourself an "artist" or not, this is a personal evaluation and, as such, has absolutely nothing whatsoever to do with the performance of your duties as a teacher. As I wrote in *Paste, Pencils, Scissors and Crayons:**

> "Don't disparage your own abilities, for if you belittle yourself, what is the message here for that little kid whose talents may be less than your own? Remember, you're the Ambassador of Trying. It's your code—live by it!"

As to the wide variety of lessons that you'll find in this book, all can be approached in fun, yet all have serious intent. Every lesson is one that teaches. Some teach in a direct and forthright fashion and are seasoned with fun along the way, while others begin with fun and teach by joyful subterfuge.

*Parker Publishing Company, 1979.

Although I have arranged the contents into chapters, the order in which the chapters appear is considerably more arbitrary than sequential. So use this book as you would a resource supermarket; wheel your mental shopping cart through the wide aisles and choose whatever seems to be the most appropriate to your classroom needs. I guarantee that you'll find enough here to keep you busy for a long, long time to come!

And certainly, don't be afraid to take *any* lesson and shape it to fit the character of your class. Add, subtract, multiply, or divide it into as many parts as time and circumstances suggest; *you* know your class best! Furthermore, your lessons will be all the better for whatever personal touches you can add, for there is no substitute for a lesson taught by a teacher who is enthusiastic and involved!

But the most important message of all is this: always remember that art is meant to be pleasurable, and if there is anything that can prepare the ground for rich and rewarding lifetime interests and ambitions, it is the memory of happy childhood experiences.

Have fun!

GENE BAER

Contents

Imaginative Art
Lessons for Kids
And Their Teachers

1

Starting at the Beginning

Kids are different. They think differently from you and me. They have their own visual language. It may or may not be *your* visual language, and it may or may not be *my* visual language, but it is definitely a true language with a distinct vocabulary and syntax all its own.

So, to understand kids, it really becomes necessary to learn at least the rudiments of this language; otherwise, there is no way we can ever hope to fully understand what kids are all about.

First of all, there is no reason to believe that very young children consciously begin by trying to *draw* anything at all. Drawing is for adults and older kids; *scribbling* is what little kids do.

The first crayoned scribbles of children are usually nothing more than the exuberant expression of large muscle movements. From a little kid's point of view, there is real pleasure in watching these unplanned comet trails as they go shooting and bursting across their papers. Watching one's own scribbling is like watching fireworks—it's fun, it's relaxing, and it's filled with unexpected surprises.

1–1

1–2

1–3

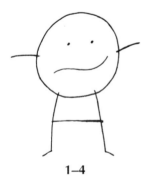

1–4

One of the unexpected surprises comes the moment that kids first begin to see the startling similarities between the closed and rounded shapes they have drawn and the fancied resemblances of these shapes to the human head. (See Figure 1–1.)

At this point, "Eureka!" The scribbler has one foot across the threshold into the world of pictographs, the art form that will dominate the child's vision for many years to come.

After the accidental discovery of the human head, a body begins to grow. In the first attempts, the arms and legs are likely to pop out from the head like sprouts from a potato. (Figure 1–2.) Later, the potato will subdivide into a "head" and "body." (Figure 1–3.) What a real head or body actually "looks like" is of no concern to the pictographic mind of the young child; rather, it is the thought that counts. Naturalism is for 19th century ateliers; pictographs are for kids!

Once you begin to study the language of children's drawings, you will find them fairly easy to understand.

Figure 1–4, for example, is a self-portrait of a five-year-old girl. Since I know what it is because she told me, it follows that we have already established grounds for some kind of pictorial communication.

I might be able to say to her, "If that is you, then *this* is me (Figure 1–5), because I am so much larger than you."

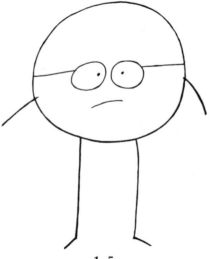

1–5

For the sake of argument, let's carry this imaginary con-
versation a little further. Let's say that my small friend and I
agree on a few other things as well:

A rectangle with four wheels represents a car. (Figure 1–6.)
And this three-wheeled vehicle is a tricycle. (Figure 1–7.)

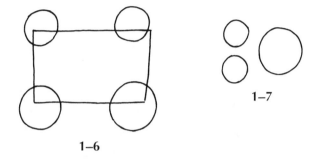

1–7

1–6

Here, then, is a picture of me getting mad at her because
she is in my driveway, on her tricycle, blocking the path of my
car. (See Figure 1–8.)

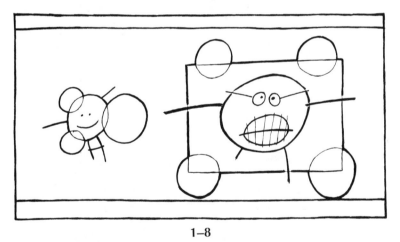

1–8

Now I know what this picture means and you know what
this picture means, but I don't suggest that you show it to your
neighbor across the way unless you are prepared to listen to
guffaws; for you, the little girl and I have the beginnings of a
pictorial communication system to which your neighbor is not
privy. To him, our "scribbles" appear to be pure nonsense,
and perhaps they are, but let me butt-in with one important
question: just how far removed is our picture code from other,
more established forms of communication? With this question

mark still dangling and our driveway "scribble" still fresh in our minds, let's take a good look at the two picture codes represented below in Figures 1–9 and 1–10.

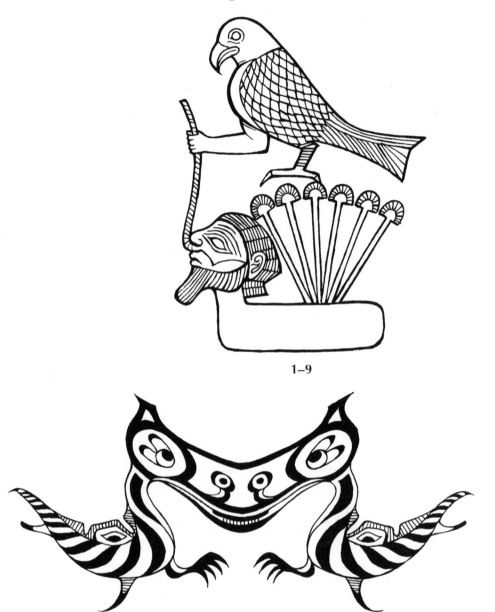

1–9

1–10

Except for aesthetic content, you'll have to admit that, without a pictorial key, the above pictures are about as mean-

ingful to most of us as a Chinese gong concert. Perhaps our driveway drawing is less forceful and has less style and design quality than either the Egyptian or the American Indian examples, but unless you are a budding Egyptologist or a cultural anthropologist who specializes in the split-view mentality of North American Indian art, you must agree that (to us, at least) our scribbled driveway scene makes a lot more sense!

Kids think so, too.

KIDS: SLICES AND STEAMROLLERS

Once you get the hang of how kids invent their own pictographs, the next thing is to understand is their approach to space.

Although it doesn't seem *that* long ago that we were children, most of us have already forgotten how kids think.

To begin with, very young children have no great interest in establishing any kind of spatial format that relates to our adult way of seeing. "This is me, this is my dog, and this is where he threw up last night." If you have any other questions—ask!* Most artists of this age group are not the least bit shy! (See Figure 1–11.)

1–11

The drawings of older children take another direction as they begin to relate to a base line, but don't rush to conclusions. This attachment to a base line does not signal an approach to "realism," at least as you and I might use the term. Instead, the world they see and the way they see it is more akin to the sectional drawings of engineers and draftsmen than it is to the len's-eye view of Western art. (See Figure 1–12.)

Unlike the old Greek philosophers who divided the world into the elements of fire, earth, air, and water, these kids sectionalize their universe into earth, air, and sky. What a beautiful conception—the visual world presented as a *slice!*

Although the *slice* can easily handle the childhood concepts of "high and low," obvious problems arise when you ask the child to show "near and far." For example, try to imagine that you are a child, and that you have just been asked to solve the problem that begins in Figure 1–13.

1–12

*Many kindergarten teachers do just that, and after listening to the artist's verbal description of the picture, they print this message in capsule form somewhere on the periphery of the picture. Although I don't remember seeing the example used above, I have seen others equally explicit!

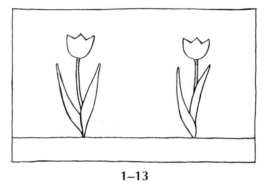

1–13

If this is how you would normally draw two flowers, how would you communicate the idea of two other flowers, one near and one far away? (See Figure 1–13.)

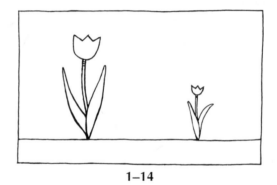

1–14

No. In child language that is a picture of one large flower and one "baby" flower. (See Figure 1–14.)

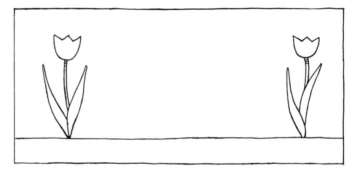

1–15

No, no. I mean *really* far away, not just separated laterally. (See Figure 1–15.)

Good try, but wrong again. In child language, what you have just drawn is a picture of one small flower above the ground and one large one *underground*. (Figure 1–16.)

Give up? The answer may seem like a cop-out, but kids aren't stupid. Faced with this kind of a problem, the child takes one schematic view and weds it to another: the frontal to the aerial. Here then, is a correct answer: an aerial view of a garden, with front view flowers. It is, more or less, what your garden would look like if it were run over by a velvet steamroller. (See Figure 1–17.)

I have taken the time to discuss the *slice* and the *steamroller*, not because I wanted to impress you with my insights into the spatial conventions of children, but rather to confront you with the thought that if you are going to arrange lessons for kids, it helps to have some idea of where *they* are starting from.

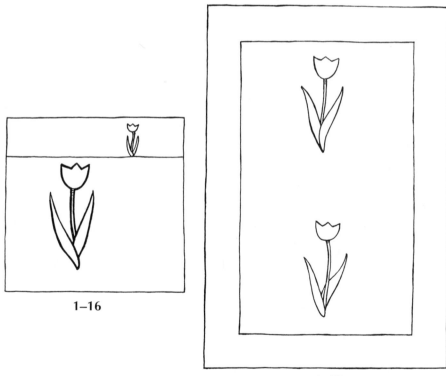

1–16

1–17

Thus, the more you know about kids, the better your art lessons will become!

2

Creative Spurs

Creative Spurs are not "lessons" in the usual sense of the word, for their main function is not to teach but to stimulate the imagination.

For highly creative children, the very concept of a *creative spur* is enough to open the doors to all kinds of strange and wonderful inventions.

For the children of lesser talents, or for those for whom creativity is difficult, the imaginative use of spurs can often mean the difference between unproductive lethergy and spirited, creative excitement.

But what about the average kids? To these kids—*creative spurs* are nothing more than just plain fun!

STARTERS

Some of the most successful classroom lessons can often be launched from *Starters*, simple gimmicks that serve to spur kids into an imaginative state of mind.

One of the most effective starter lessons is nothing more than a felt-tipped pen line, scribbled by the teacher, on a sheet of drawing paper. (See Figure 2–1.)

2–1

Instructions: Have your kids use their crayons to incorporate this scribbled line into some kind of imaginative picture.

To illustrate the wide range of possibilities here, the following examples show how two different people (or the same person at two different times) might arrive at two entirely different answers! (See Figures 2–2A and 2B.)

Another simple *starter* lesson can be built around a handful of simple shapes cut from a sheet of colored construction paper.

Instructions: Have you kids choose a shape, paste it on a piece of drawing paper, and use their crayons to incorporate this shape into a picture of their own invention. (See Figures 2–3A and 3B.)

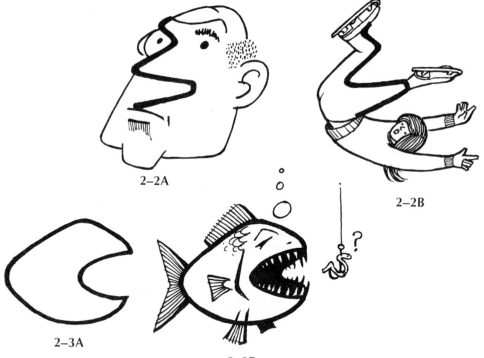

2–2A

2–2B

2–3A

2–3B

A great *starter* at Christmas time is to have your kids cut out a simple green triangle, paste it onto a sheet of drawing paper, and then turn them loose to decorate their trees with ornaments, presents, etc. A sprinkle of gum-backed colored stars will add an additional festive note.* (See Figures 2–4A and 4B.)

*For a more detailed presentation of this, the preceding lesson, and dozens of other imaginative *starters*, see my *Paste, Pencils, Scissors and Crayons* (West Nyack, NY: Parker Publishing Company, 1979).

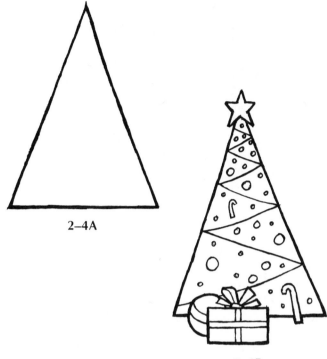

2–4A

2–4B

HAND STARTERS

Incredibly simple and yet unfathomably complex, the human hand has always fascinated the human mind.

The word "spider," accompanied by the motion of your hand "running on its five bony spider-legs across a table-top, is enough to bring shrieks of excitement from small children. (See Figure 2–5.)

A hand "walking" on two fingers can easily be seen as a person, and two finger-people "dancing" side by side always manage to make a pretty fair song and dance team! (See Figure 2–6.)

2–5

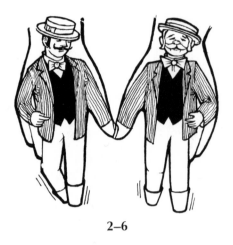

2–6

The traced hand, among the first drawings and samples on cavern walls, pre-dates written history. For this reason, it is not entirely accidental that many of my best *starter* lessons begin with the traced hand!

Like a lot of other instructions for children, hand tracing directions are easy to give, but sometimes difficult to follow. The best hand tracings are made when the pencil is held in a vertical position. With this simple observation in mind, the teacher can easily see—even at a distance—those children who have followed instructions and those who need additional reminders. (See Figure 2–7.)

The easiest way to present *hand starters* is simply to trace your own hand on the chalkboard and work along with the kids. For more elaborate drawings, use a soft lead pencil and

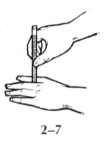

2–7

a sheet of white drawing paper taped to the chalkboard or wall.

Keep in mind that there is nothing sacrosanct about a *hand starter* (or, for that matter, any *starter!*), and that copybook perfection does not win the prize. Use these *hand starters*

alone or in multiples as needed. Your job is simply to use whatever measure of guile necessary to ignite a child's imagination. Once your classroom's collective adrenalin is cooking on high heat, my best advice is to get out of the way and let their imaginations soar free: they'll do the rest!

Lesson #1 A Bird in the Hand

One of the easiest of all *hand starters* is the "Bird in the Hand"; it is easy to do, easy to repeat, and easy to put to good use!

1. Have your kids trace their hands in this position. (Lefties will have to reverse all directions.) (See Figure 2–8.)

2. Turn the paper so that the hand-tracing now looks like Figure 2–9.

3. Complete the bird so that it looks something like Figure 2–10.

Or like this! (See Figure 2–11.)

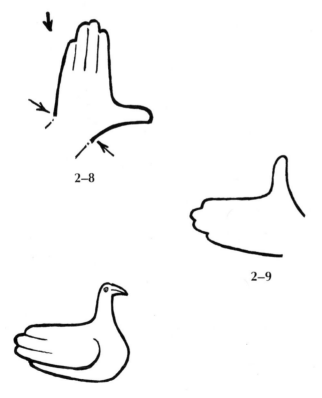

2–8

2–9

2–10

2–11

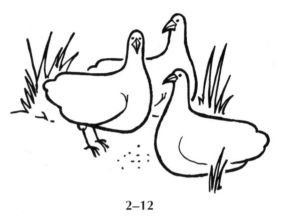

2–12

Here are some additional ideas in Figures 2–12 and 2–13.

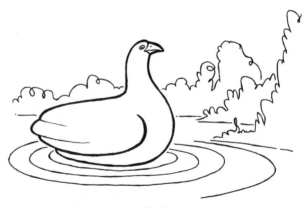

2–13

A Higher Bird

Anyone who has ever made hand-shadows on a wall knows that birds and hands have a great similarity to each other. Here is one way to show your kids how to make a flying bird! (See Figure 2–14.)

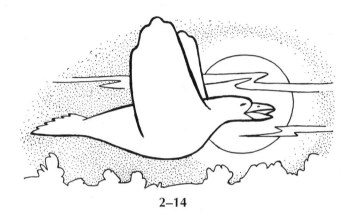

2–14

1. As in the bird lesson on the previous page, have your kids trace a hand in this position. (See Figure 2–15.)

2. Keeping the hand-tracing in the same position, complete the head, add the underbelly, a few tail feathers, and whatever can be seen of the other wing. (See Figure 2–16.)

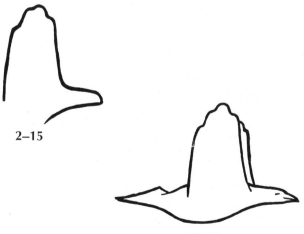

2–15

2–16

Instructions for Older Kids

Each age has its own standards. In kindergarten, a cray-oned bird with four legs is not something to ridicule, but rather, a matter of choice. Older kids, on the other hand, are generally a little more demanding! So for *their* birds, here are instructions for a more sophisticated flying model:

1. Have your kids trace their hands in this position, but instruct them to leave the end of the hand "open." (See Figure 2–17.)

2–17

2. Continue as in the previous lesson, but add the additional sweep to the wings! (See Figure 2–18.)

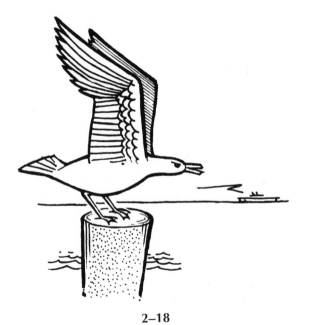

2–18

Lesson #2 Turkey Birds

Ever since the Pilgrims found them good to eat, Turkey Birds have been a traditional part of our classroom culture. And almost as popular as the Thanksgiving dinner itself is the old kindergarten lesson of making a turkey from a hand-tracing. But, as you can see from the typical hand-turkey pictured here, the old boy could use a little help! (See Figure 2–19.)

1. Have your kids place their hands in this position (with the thumb held close to the hand), but rather than asking them to trace the whole hand . . . (See Figure 2–20.)

2. . . . have them trace only the hand and the thumb—*not* the fingers! (See Figure 2–21.)

3. From here on, it should be easy. Close up the top of the turkey's body with a line, and add the tail feathers, as in Figure 2–22.)

2–19

2–20

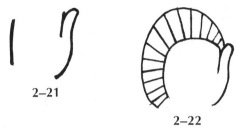

2-21

2-22

4. Finish the head and neck, and add the triangular wings. (See Figure 2-23.)

5. Once the feet are on and a few finishing touches are added, you have a turkey that you can be proud of! (See Figure 2-24.)

2-23

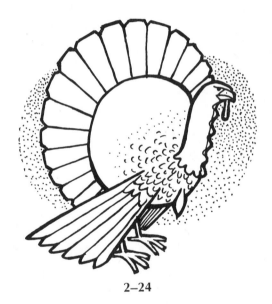

2-24

Lesson #3 Hand-Dogs

Although they are of no particular breed, these happy mongrels will never lack attention! (See Figure 2-25.)

2-25

Instructions for Little Kids

1. Have your kids trace their hands in the position in Figure 2-26.

2. Turn the paper so that the hand-tracing now looks like Figure 2-27.

3. Complete the line of the back, and add the features, ears and tail! (See Figures 2–25 and 2–28.)

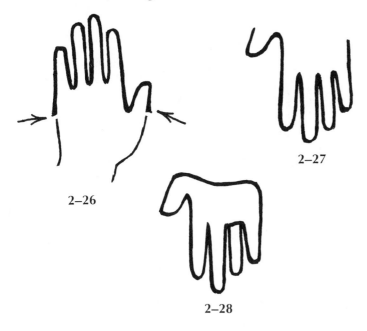

2–27

2–26

2–28

Instructions for Older Kids

1. Have your kids trace their hands in this position . . . (See Figure 2–29.)

2. . . . but when tracing the hand, delete the ring finger. (See Figure 2–30.)

3. This small change will allow the older child to draw a shorter, more realistic-looking back leg (a structural change that would be meaningless to little kids). (See Figure 2–31.)

2–29 2–30

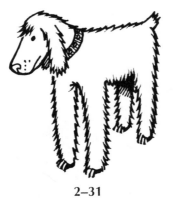

2–31

Lesson #4 The King with the Long Pedigree

One of the easiest of all the *starters* is this King—and the kids love him! (See Figure 2–32.)

1. Have your kids trace their hand and arm in this position in Figure 2–33.

2. Draw in the features of the head and the details of the crown as in Figure 2–34.

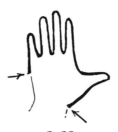

2–33

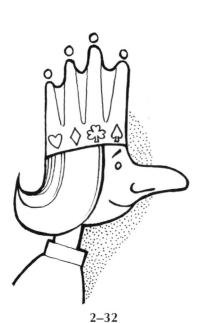

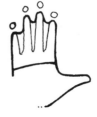

2–34

2–32

3. Encourage your kids to add arms and to dress the King in a fashion appropriate to his rank. Add background details and admire!

Lesson #5 A Pretty Good Horse

Although hardly a photographic likeness of a horse, this good-natured hand-horse is certainly as believable as Christopher Robin's "Eeyore" and twice as easy to make! (See Figure 2–35.)

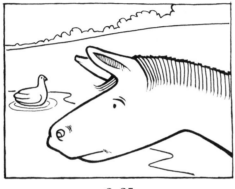

2–35

1. Have your kids trace their hands in the position in Figure 2–36. (Note the angle of the hand in relationship to the arm.)

2. Turn the drawing as shown in Figure 2–37.

3. Once the features have been added, the rest of the picture is just begging for completion! (See Figure 2–38.)

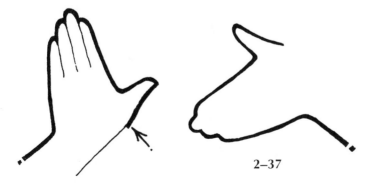

2–37

2–36

2–38

Lesson #6 An Easy Indian

Indians are always popular, and here is one way to *increase* their popularity! (See Figure 2–39.)

2–39

2–40

2–41

1. Have your kids place their hands in this position, with the thumb turned under. (Older kids may want to taper rather than round the ends of their traced fingers.) (See Figure 2–40.)

2. Begin by drawing the headband and completing the chin line as in Figure 2–41.

3. Add the hair and the features, complete the feathers, and decorate the headband. (See Figure 2–42.)

4. Have your kids add additional feathers and finish the picture in any manner they want.

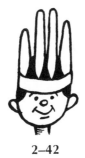

2–42

Lesson #7 A Handy Elephant

Anyone who insists that they "can't draw" has to be somebody who has never met up with this "Handy Elephant"! (See Figure 2–43.)

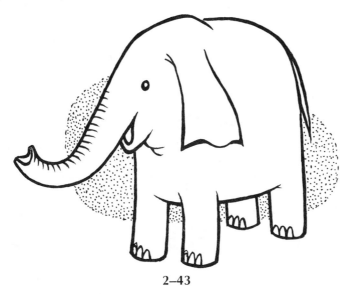

2–43

Instructions for Little Kids

1. Have your kids trace their hands in the position in Figure 2–44. . . .

2. . . . but only trace up the side of each finger to the central knuckle. (See Figure 2–45.)

3. Then, turn the tracing upside down so that it looks like this, then draw in the bottom of each of the legs and the line of the back. (See Figure 2–46.)

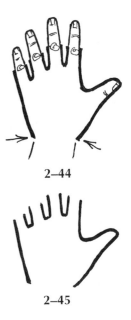

2–44

2–45

2–46

4. The rest is easy; just add the mouth, eye, ear, tail, and, of course, the toenails! (See Figure 2–47.)

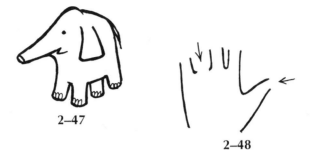

2–47

2–48

Instructions for Older Kids

1. Follow the same instructions as above, but delete the line of the ring finger and leave the end of the thumb "open." (See Figure 2–48.)

2. These changes allow the older child an opportunity to lengthen the trunk and add a more convincing back leg. (See Figure 2–49.)

2–49

Lesson #8 A Tricky Turtle

Many of the *hand starters* hardly use the hand at all. This "Tricky Turtle," for example, needs only three stumpy fingers and a thumb tip! (See Figure 2–50.)

2–50

1. Have your kids place their hand in this position . . . (See Figure 2–51.)

2. . . . but trace only those parts of their fingers and thumb as are shown in Figure 2–52.

3. Turn the tracing upside down, then draw in the bottom of each of the legs and the gentle curving line of the bottom of the shell. (See Figure 2–53.)

4. Add the details and send this creature on its way! (See Figure 2–54.)

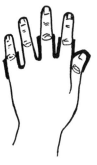

2–51

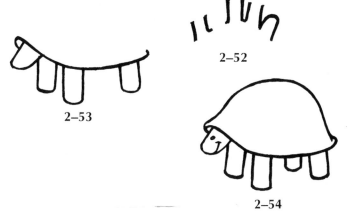

2–52

2–53

2–54

Lesson #9 Hand-Animals for Older Kids

In Lesson #3 and #7 of this series, I introduced you to the basic "Hand-Animals": the Hand Dog and Elephant. More advanced "Hand-Animals" take a little more time, but I think you'll find them worth the additional effort.

Making Hand-Dogs Sit

1. Have your kids trace only that part of their hand shown in Figure 2–55.

2. Turn the tracing upside down, as in Figure 2–56.

3. And finish! (See Figure 2–57.)

2–56

2–55

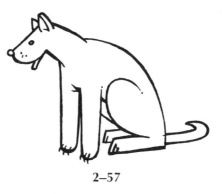

2–57

Suggestions for drawing the back legs of sitting animals: for animals facing left, use a backwards "2"; for animals facing right, use a regular two (lefties will like this one!). (See Figures 2–58 and 59.)

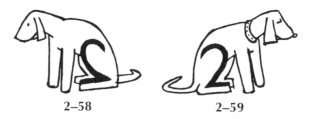

2–58 2–59

The Bear

Bears are easy to make and here's how to make them!

1. Have your kids trace their three fingers and thumb tip as shown here. Then invert the tracing. (See Figures 2–60A and B.)

2. Begin as in the "Hand-Dog," but keep the outline shaggy. Add circular, bear-like ears and a short, stumpy tail. (See Figure 2–61.)

2–60A

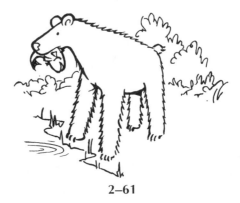

2–60B

2–61

The Reindeer

Since very few people in my corner of the globe know anything at all about reindeers or spend much time in their company, most are quite willing to accept my "Hand-Reindeer" as being a reasonably faithful portrait of one of Santa's best!

1. Have your kids trace the same three fingers and thumb tip as used in "The Bear" drawing above. For the very best reindeer, instruct your class to make their finger tracings "skinny." (See Figure 2–62.)

2. The back of a "Hand-Reindeer" is not a great deal different from that of other "Hand-Animals." It is in the full and flowing hair of the neck that reindeer begin to acquire their unique visual personality. Ears and antlers complete the portrait. (See Figure 2–63.)

2–62

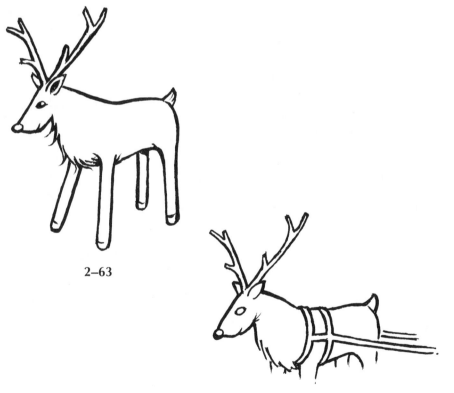

2–63

2–64

3. If the reindeer is to pull a sleigh, here is one way to make a convincing reindeer harness. (See Figure 2–64.)

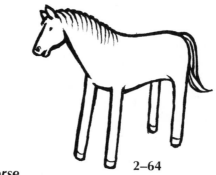

2–64

The Horse

Since everybody knows (or think they know) what a horse "looks like," convincing horses are hard to draw. Like all simplified horse schemas, the "Hand-Horse" is not perfect—but for beginning horse artists, it is as good a place to start as any!

1. Keeping their fingers fairly close together, have your kids trace their hands as shown in Figure 2–65. As in the case of the reindeer, the horse is more successful when the finger tracing is kept "skinny."

Turn the tracing upside down. (See Figure 2–66.)

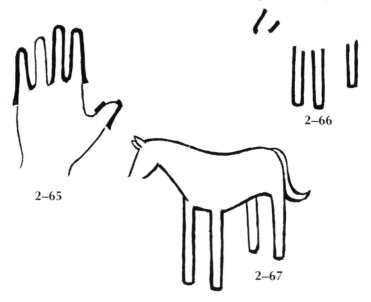

2–66

2–65

2–67

2. Since the proportions are about right, the rest is easy. Just fix up the tracing to make it look like a horse! (See Figure 2–67 and the Lead Illustration.)

Lesson #10 The Dragon

Like Japanese movie makers, boys prefer dragons that breath fire and ravish cities; girls, on the other hand, prefer housebroken dragons with more domesticated manners. Either way, here is one quick way to find out what kind of dragons *your* class prefers!

1. Have your kids trace their hands as shown in Figure 2–68.

2. Turn the paper upside down and begin as in other "Hand-Animals," but this time add a long, pointed tail. (See Figure 2–69.)

3. As to dragon-like features, leave that to your kids— they'll have all the ideas they'll need! (See Figure 2–70.)

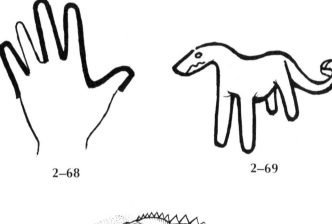

2–68 2–69

2–70

Lesson #11 Hand-Trees

"Hand-Trees' have a lot to recommend them; they are easy to draw, they are nicely proportioned, and they come in five styles!

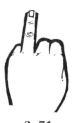

2–71

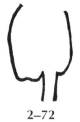

2–72

1. Make a fist with one extended finger, then trace as shown in Figure 2–71.

Then, turn the drawing upside down. (See Figure 2–72.)

2. And finish! (See suggestions in Figure 2–73.)

The Five Basic Hand-Trees

Thumb	First Finger	Middle Finger	Ring Finger	Little Finger

2–73

ADVANCED PROJECTION TECHNIQUES

Ever since Freud introduced the term "projection" to describe the act of externalizing our thoughts, psychologists have embraced this concept as they would one of their own children. The truth, however, is of mixed parentage, for *long* before the word "projection" crawled upon the good doctor's couch, it was a nameless activity well-known to the art world. It is a matter of record that projective techniques were commonly employed by both Leonardo da Vince and Piero di Cosimo as a practical and effective means by which these great masters spurred their visual imaginations.*

Anyone who has ever amused himself with the ink blots of the Rorschach Test is already an initiate of basic projection. Although Hermann Rorschach is given credit for discovering a diagnostic use for the ink blot, its recreational use must date back to the invention of paper, for it certainly doesn't take kids long to discover that a folded paper will spread a contained blot into the most bizarre and unexpected of shapes. Once you can get your kids to understand that the bird, the plane, or the Superman they see in the burning embers of a fire, in the billows of a cloud, or in the dried puddle of an ink blot is not "there" at all, but is instead projected from the human mind like slides flashed onto a projection screen, then the stage is set for the near-mystical experience of creative projection.

The task is one of seer and seen, of first "seeing" and then finding the means by which these private visions can be communicated to others. The first demands a receptive state of mind, the second is a call for art materials. This double task does not come easily to everybody, but if approached sensitively, the results will amaze everyone including the artists themselves.

I have been teaching for a long time, and have tried all kinds of off-beat lesson plans, but I will have to admit that while the following five lessons can be difficult to present, the

*While Leonardo advised the artist to find his inspiration in "a wall spotted with stains or with a mixture of stones," Vasari tells us that Piero di Cosimo "stopped to examine a wall where sick people had stopped to spit, imagining that he saw there combats of horses and the most fantastic cities and extraordinary landscapes ever beheld." (These lessons are not included here.)

price is right, for some of the most remarkable student crea-
tions I have ever seen were wrenched from the unconscious by
one or another of the following lessons.

Lesson #1 Projections by the Numbers

This lesson is perfect for bridging the gap between *starter*
lessons and *projections,* for by assigning the same problem to
everyone and offering no clues to its solution, the child has an
opportunity to see for himself the diversity of the human mind
at work!

1. Simply give your kids paper and pencils and ask them
to draw a zero. Their assignment is to try to turn this zero into
a recognizable picture.

Typical answers might be found in Figures 2–74A-D.

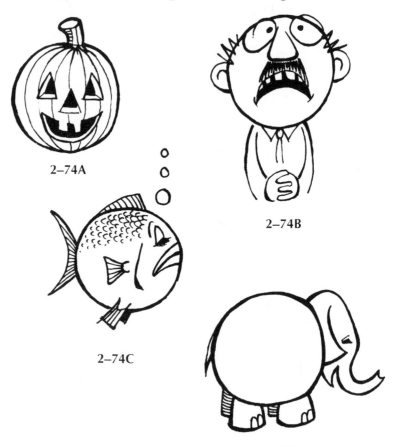

2–74A

2–74B

2–74C

2–74D

2. After a minute or so has passed, compare their results and invite volunteers to the chalkboard to show off their inventions.

3. Continue playing this "game," using all of the numerals from 1 through 9. Here are a few examples of some of the kinds of things you can expect your kids to find. (See Figures 2–75A-I.)

2–75A

2–75B

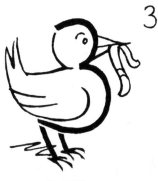

2–75C

2–75D

2–75E

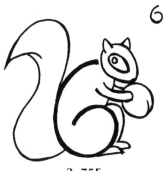

2–75F

2–75G

2–75H 2–75 I

Lesson #2 Scribble Projections

One of the simplest of all projection techniques is the single-line scribble that was explained earlier in this chapter. This lesson is similar, but is considerably more sophisticated.

1. Have your kids make a large, loose, lightly-drawn scribble on a sheet of paper. (See Figure 2–76.)

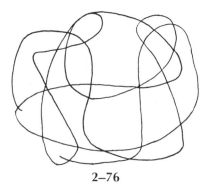

2–76

2. Once the scribble is drawn, begin to promote the whole idea of finding pictures in scribbles. Explain that the ultimate in "scribble seeing" begins when one begins to see

whole pictures, complete with background, but that this is hard to do. As a result, the best advise is to begin with what they see, and then add to it. Warn against two things only: (1) taking the scribble too literally, and (2) being too timid to "fake it" through those areas in which the scribble transmissions are either cloudy or non-existant. (See Figures 2–77 and 2–78.)

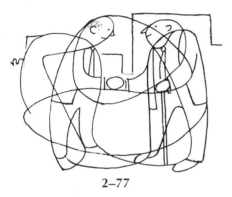

2–77

2–78

Additional Suggestions: For those kids who have trouble getting started, continually remind them that until they are well underway, the paper has neither top, bottom, nor sides. Until that time, they should feel free to keep turning the paper until they reach the place where the first productive images begin to appear.

For those kids whose visual imaginations are at a low ebb, help them out by showing them something that *you* see in their picture and encourage them to start with that!

Here are a couple of scribble projections that I drew to occupy my mind during yesterday's long and boring faculty meeting: (See Figures 2–79 and 2–80.)

2–79

2–80

Lesson #3 Marbleized Crayon Pictures

The only marbleizing lesson you will find in most art activity books is one that uses oil-based paints, but oil paint stains hands, ruins clothes, and needs extended drying time.

My marbleizing process has none of these classroom disadvantages. Whether this process is used as a projection technique or simply as a funtime experience, I know of few art lessons that can offer this kind of bright, colorful, and satisfying excitement; I cannot recommend it too highly!

YOU NEED:

a hot plate

odds and ends of crayons

lightweight white cardboard (bristol board is ideal!)

a small baking pan, a foil loaf pan, or simply a sheet of
heavy foil turned up on the sides to hold water.

a pair of pliers (preferably needle-nosed)

TO PRESENT:

1. Simply heat water in a pan, drop in a couple of as-
sorted crayons, and watch them melt. The temperature of the
water is important: it should be hot but not too hot, and cer-
tainly not boiling (but you will quickly learn the right temper-
ature through experimentation). (See Figure 2–81.)

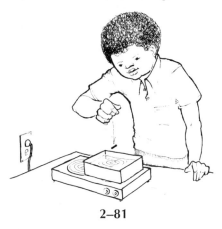

2–81

2. Cut your cardboard into whatever sizes will fit conve-
niently into your pan of hot water. Nip two of these pieces
back to back at one corner; dip in, take out, and set down to
dry. The whole process, including the drying, takes longer to
write about than it does to complete. (See Figure 2–82.)

2–82

If the purpose of this activity is just to marbleize paper,
then that's all there is to it. Just continue repeating the process
until your crayon and cardboard stock is depleted.

On the other hand, if you plan to use these sheets for pro-
jection purposes (as I do), read on!

3. To use these marbleized sheets as a basis for a projected picture, simply instruct your kids to approach this project in a projective frame of mind, and to add crayon wherever crayon is needed to help communicate their private visions to others.

If your class responds as well as mine, your results will be absolutely outstanding. (See Figures 2–83A and B.)

Do it!

2–83A 2–83B

Lesson #4 Seaweed Pictures

If you are fortunate enough to live near the ocean, then these "Seaweed Pictures" are for you!

YOU NEED:

2–84

a bucket of water and a strong boy or girl to transport your seaweed

stiff, white lightweight cardboard (bristol board is ideal; file cards work well for small pictures)

drawing pens or fine-line markers

TO PRESENT:

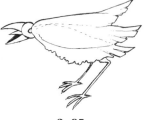

2–85

1. Simply pass out the cardboard and have your kids arrange the wet seaweed into interesting patterns.

2. Once the seaweed has dried, it will adhere to the cardboard with its own "glue." Many of these "Seaweed Pictures" may prove to be spectacular enough for immediate classroom display, while others will beg for just a touch or two of line to give them character and compositional unity. (See Figures 2–84 and 2–85.)

3. Large varieties of seaweed such as "sea lettuce" are natural beauties in themselves. For these: simply spread them out, let them dry, and display! (See Figure 2–86.)

2–86

Lesson #5 Smoke Screens

Like many of the other *Advanced Projection Techniques*, these "Smoke Screens" are an exquisite natural-art form in themselves. The fact that they are creations of accidental parentage detracts in no way from their pure and sensuous beauty.

YOU NEED:

white drawing paper

pen and ink, a fine-line black marking pen, or any other black-line drawing instrument.

a candle and a match.

TO PRESENT:

1. The "Smoke Screens" are prepared by moving a lit candle close enough to the surface of the paper to leave a pattern of flowing carbon trails. (See Figure 2–87.)

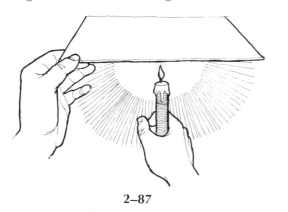

2–87

2. Using the "Smoke Screens" as they would any other projection technique, have your kids use their pens to turn these smoke paintings into imaginative pictures. (See Figure 2–88.)

2–88

Lesson #6 Bump Pictures

Of all the projection techniques, this is undoubtedly the zaniest!

YOU NEED:

 white cardboard (5 × 7″ is not too small)

 poster paint

 paste

 paper towels

 masking tape

 scrap paper

TO PRESENT:

1. Have your kids wrinkle up a ball of paper towel about the size of a large cherry or small walnut, and tape it to the surface of their cardboard. (See Figure 2–89.)

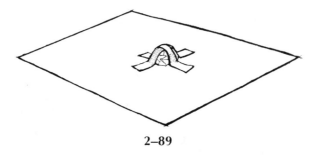

2–89

2. Using strips of scrap paper and paste, carefully papier mâché this miniature "hill" to the cardboard to make a smooth painting surface. (See Figure 2–90.)

2–90

3. From this point on, it takes very little persuasion to convince your kids that this can be turned into an imaginative picture and finished with poster paints! (See Figure 2–91.)

2–91

3

Seasons, Holidays, and Kids: Getting Off to a Good Start

Adults pretend to measure the passing of time in calendar years, and in honor of this event, they set aside New Year's Eve to salute the old and ring in the new. Or so they say. Kids are much more honest; they measure their lifespan in *birthdays* . . . and to a kid, the distance between one birthday and another is a millennium!

Since a year is such a long time to a child, seasonal and holiday celebrations are not just "extras" to be added like frosting to the top of a well-planned curriculum. Instead, they are an essential part of that curriculum for they refresh the spirit, reinforce the feeling of cultural identification, and form the basic building-blocks from which children learn the meaning of calendar time.

While some adults can manage a bored yawn on the first day of Spring, or can go about grumbling about the jingle of cash registers on St. Valentine's Day, kids love these festive events and look eagerly forward to their arrival. If *you* can find enough ways to weld this enthusiasm to your classroom program, your kids will love you for it.

In the pages that follow are dozens of high-grade, sure-fire lesson plans, all neatly arranged in school-year order!

So *celebrate!*

AUTUMN

September 23—December 21

To many adults, Autumn (or Fall) is a sad but beautiful season; sad because it reminds some that they are growing older, and beautiful because—at its best—the autumn palette can be absolutely breathtaking. Furthermore, nowhere in this world is this beauty more spectacular than in those temperate regions of this country where the coming of Winter is heralded by an unforgettable burst of color.

However, to kids, the color of the foliage is not all that important; what is important is that Autumn is a new *season*. While leaves may be colorful, this is not their primary function. Leaves are for playing with, for throwing, for jumping in. Who cares about the death of Summer when Halloween is in the air? And after Halloween, there is Thanksgiving and the excitement that leads to Christmas. So what's sad about Autumn? Nothing. Ask any kid. Autumn is one of the best and the happiest seasons of the year.

Technically, Autumn arrives on September 23, but chances are that nobody in your classroom is going to know this fact unless you tell them. Then, after you announce it, let your kids celebrate it with a lively, seasonal art activity!

Lesson #1 The Autumn Squirrel

There are two problems with celebrating the first day of Autumn: the first is knowing *when* to celebrate it, and the second is knowing *how* to celebrate it. It follows then that what Autumn needs is a good publicity department.

The first step is to decide upon an appropriate anthropomorphic symbol. Christmas has a Santa Claus, Easter has a humanoid rabbit, St. Patrick's Day has a Leprechaun—but what does Autumn have? A dancing leaf?

Obviously this whole season has long been suffering from a dearth of imaginative leadership. It is for this reason that I have appointed myself chairman of the Autumn Promotional Council, a non-profit organization whose primary function is to proclaim the squirrel:

King of the Autumn
Festival!

YOU NEED:

practice paper
drawing paper
pencil and crayons

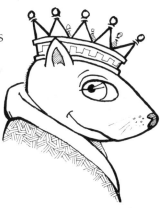

TO PRESENT:

Mickey Mouse, Donald Duck, Bugs Bunny, Snoopy—
these are only a few names attesting to the box office popular-
ity of anthropomorphic animals. Surely no one believes that
these "funny creatures" are supposed to represent *real* ani-
mals; and so it is with the "Autumn Squirrels." Here is how I
draw them:

3–1A

1. The head of the "Autumn Squirrel" is basically egg-
shaped. Once the egg is drawn, the nose and the forehead are
given a distinct, off-centered, roof-shaped character. Add a
nose and mouth, and large eyes. (See Figures 3–1A, B and C.)

2. When drawing the body of the squirrel, the only in-
structions are to keep the body small, the tail large, and the
hands and feet tiny. (See Figure 3–2.)

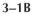

3–1B

3–2

3–1C

3. *Question:* How should an "Autumn Squirrel" be dressed? *Answer:* The "Autumn Squirrel" should be dressed to fit the occasion. (See Figures 3–3A and B.)

3–3A 3–3B

4. After your kids have tentatively sketched out a few squirrels on their practice paper, pass out the drawing paper and let them go to work!

Long Live the Autumn Squirrel!

COLUMBUS DAY

2nd Monday in October

3–4

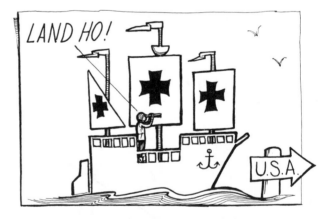

Since there were no staff photographers aboard the Santa Maria, all pictorial celebrations honoring Columbus will just have to be based upon some thin, educated guesses and some strongly imaginative interpretations. So when in doubt, do what the professional historians do—invent!

With little kids: if your Columbus Day activities accomplish little more than introducing Christopher Columbus as a famous sailor who sailed across the wide Atlantic, you will

have set the stage for other Columbus Days and other Columbus stories.

With older kids, Columbus Day is the perfect time to get into discussions of wind and sail, and the early misconceptions of world geography. Even today, I am told, there are people who honestly believe that the world is flat as a disk, with the North Pole as its center and Antarctica encompassing the perimeter. (Try to explain *that* to your class!)

Lesson #2 "How Do You Make a Columbus Boat?"

Although the successful celebration of Columbus Day can (and will!) feature all kinds of anachronisms (outboard motors, pirate flags, and radar antennae are commonly found in classroom caravels), Columbus Day is as good a time as any to introduce some primary shipbuilding skills!

YOU NEED:

construction paper:

 12 × 18″ light blue

 3 × 9″ brown

 3 × 5″ and (two) 2½ × 3½″ yellow
paste, pencil, scissors, and crayons

3–5

TO PRESENT:

1. Have your kids trim up the 3 × 9″ brown paper so that it resembles the basic hull of a caravel. (See Figure 3–5.)

2. Cut out and paste the hull somewhere near the bottom of the 12 × 18″ light blue paper; color in the supporting ocean, and add three masts and the forward projecting bowsprit as shown in Figure 3–6. (Note that the central or *mainmast* is the tallest.)

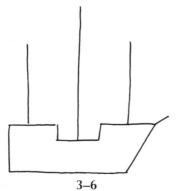

3–6

3. The larger of the yellow papers will become the mainsail; one of the smaller becomes the forward sail or *foresail*. The remaining yellow piece is then cut in half diagonally to make a lateen-rigged sail and pasted as shown in the Lead Illustration.

4. Add a crow's nest, and cut long pennants to fly from the top of the masts. Other details (railings, anchors, windows, sailors, fish, land, etc.) can be added anytime!

Lesson #3 Columbus Day Silhouette

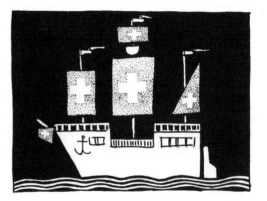

At first glance this "Columbus Day Silhouette" may appear to be nothing more than a heavy-handed "do as I do" lesson, but don't be too quick to draw conclusions. Thoughtfully presented, this lesson teaches everything from intermediate shipbuilding to advanced silhouette making. When the lesson is done, not only will every child have a finished caravel, each with its own personality, but the assembled pictures will also make as attractive a flotilla as ever sailed a classroom sea!

YOU NEED:

construction paper:
9 × 12" and 4½ × 6" in assorted colors,
paste, pencil and scissors

TO PRESENT:

1. Have your kids choose two sheets of contrasting 9 × 12" paper (one light, one dark). Trim one of the long edges of one sheet to make a graceful, snake-like curve. Throw

away the scrap and cut three more pieces parallel to the first. Paste these three "water lines" to the bottom of the second sheet of 9 × 12". (See Figures 3–7A and 7B.)

3–7A 3–7B

2. Review with your class the basic lines of a caravel's hull. Then, using the same paper from which the water lines were cut, have your kids draw a hull approximately 6" long. Cut out this hull and paste it so that it "floats" on the water.

3. Returning again to the first sheet of paper, cut out three masts, the bowsprit, the rudder and the crow's nest. (See previous lesson. Note that the central or *mainmast* is taller than the other two.) Paste down all except the crow's nest. (The best time to paste down the crow's nest is after the mainsail is in place. See Step 4.)

4. Have your kids choose a third color from the 4½ × 6" paper; cut this paper into sails, and paste into place. (See Figure 3–8.)

3–8

5. Further embellishments such as windows, anchors, pennants, Spanish crosses, etc., are added from the combined scraps. (See the lead illustration.)

Further Suggestions: Of course this lesson can be simplified by making it only a two-color silhouette; either way, it is an exceptionally decorative activity!

HALLOWEEN

October 31

In the olden days (I'm told), there were four heavily-circled dates on a witch's calendar: these were the sabbats of Candlemas (February 2nd), May-Day (May 1st), Lammas (August 1st) and Hallotide (October 31st). Since Candlemas and Groundhog Day fall on the same date, we don't hear much about Candlemas any more; the Communists have taken over May-Day; Lammas has been pretty much forgotten*; but the old pagan mythology of Hallotide lives on!

Kids love Halloween. They love ghosts, demons, haunted houses and all those mysterious things that go bump in the night—things that many adults like to pretend do not exist.

However, exist they do in the vivid imaginations of every Halloween-loving child. Except, perhaps, for birthdays and Christmas—*this* is the BIG one!

Lesson #4 Ghosts, Demons, and Witches

*The only place that I know where Lammas is faithfully celebrated is at the St. Pierre School in Vineyard Haven, Massachusetts. There it is done in style, with flickering candles, appropriate costumes and hair-raising ghost walks.

Although stuffed-paper projects are a common enough art activity, most of the stuffed-paper projects that I have seen have suffered for the lack of a good, strong, imaginative theme. On that score, no one can fault this trio of Halloween spookers.

THE BASIC GHOST

YOU NEED:

construction paper
 (two each) 12 × 18″ white
 9 × 6″ orange
 4½ × 6″ black
 small scrap of white
small ball of newspaper or other scrap paper
as many staplers as you can borrow
paste, pencil, scissors and crayons

TO PRESENT:

1. Give each child two sheets of white drawing or construction paper. On the first sheet, draw a large, but simple ghost in outline form. (See Figure 3–9.) When this drawing is complete it is placed on top of the second sheet. A couple of Temporary Staples* are then used to pin the two papers together so that they can be cut out to make a "front and back" ghost.

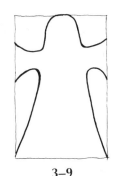

3–9

*See *ART and KIDS* Glossary.

3–10

2. Once the ghosts have been cut out, let your kids staple around the outline. The only places that are not to be stapled are openings to the sleeves and the bottom edge of the ghost. (See Figure 3–10.)

3. The hand and eyes are made from black paper, the pupils of the eyes from white scrap paper, and the pumpkin from the 6 × 9″ orange.

4. When done, open up and stuff with the ball of scrap paper. Your kids will love them! (See Figure 3–11.)

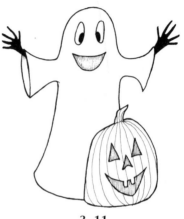

3–11

DEMONS

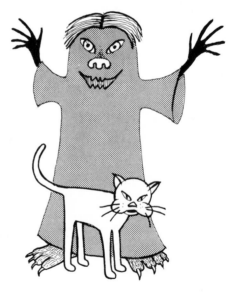

YOU NEED:

construction paper:
 (two each) 12 × 18″ orange
 4½ × 6″ black
 small scraps of orange, white, and black paper
a small ball of newspaper or other scrap paper
as many staplers as you can borrow
paste, pencil, scissors and crayons

TO PRESENT:

1. Using the large orange paper, follow the same steps as were used to make the basic ghost figure in the previous lesson.

2. Then let your kids add anything else they wish. The yellow cat and the demon's clawed feet, for example, in the lead illustration on p. 68 are *my* contribution!

WITCHES

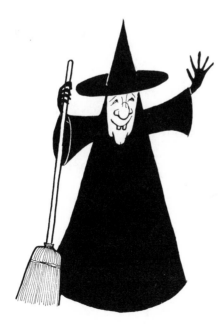

3–12

3–13

3–14

YOU NEED:

construction paper:

12 × 18″ black (two each)

6 × 9″ orange

6″ square black

6 × 9″ black

3 × 4½″ brown

⅜ × 12″ black

small ball of newspaper or other scrap paper

as many staplers as you can borrow

paste, pencil, scissors and crayons

TO PRESENT:

1. Using the large black paper, follow the same steps as were used to make the previous two lessons. Note that the witch's hat is drawn without a brim. (See Figure 3–12.) The face of the witch is made from the orange paper, with the features crayoned in. The hands are also made from the orange paper.

2. The hat brim is a circle cut from the 6″ square of black paper, and prepared with radial cuts as shown here in Figure 3–13.

3. After the radial cuts are made and the figure has been stuffed with the ball of paper, the hat is slid down over the head until it meets with the orange line of the forehead. (See Figure 3–14.)

4. The long thin strip of black is destined to become the broom handle, the small orange sheet becomes the working end of the broom.

5. Let your kids add anything else they wish and your witches are complete!

Lesson #5 Masks for All Occasions

Kids love to make masks; the only problem with mask-making is that Halloween comes but once a year; that is, of course, unless you also want to celebrate the sabbaths of Candlemas, May-Day and Lammas! (See p. 66.)

In any case, here are enough mask ideas to keep you busy for Halloweens to come!

T-MASKS

YOU NEED:

construction paper
12 × 18" and 4½ × 6" in assorted pastel shades
12 × 18", 9 × 12" and 4½ × 12" in assorted dark colors
paper punch
paste, pencil, scissors and crayons

3–15

3–16

3–17

TO PRESENT:

1. Have your kids fold a sheet of 12 × 18" pastel paper in half lengthwise. About a third down on the folded side of the paper, punch out an "eye hole" with your paper punch. Have your kids enlarge this hole with their scissors so that when the mask-in-the-making is held up to the face, the vision is clear and unobstructed. (See Figure 3–15.)

2. About halfway between the "eye" and the "chin," make a "nose" cut in the folded paper as shown in Figure 3–16. Unfold and cut up on the center fold from the "chin" to the "nose." See Figure 3–17.) Overlap these two adjoining sides of the cut center and paste in such a way that a protruding "nose" becomes quite pronounced. (See Figure 3–18.)

3–18

3. Draw in the eyes and the mouth with crayon. The ears are made from the 4½ × 6″ piece.

4. When it comes to the dark hair, your kids must choose between three lengths: long (12 × 18″), medium (9 × 12″), or short (4½ × 12″). If the 12 × 18″ hair is chosen, then the hair-piece is folded lengthwise; for the other two lengths, fold the hair widthwise.

Short Hair: For the short hair, all that is needed is to fringe the bottom and paste it into place. (See Figure 3–19.)

Long and Medium Length Hair: To prepare these hair lengths, have your kids cut out a rectangular area as indicated by the shaded areas in Figure 3–20A and B. Then unfold the paper and cut the hair into long strands. If desired, curl these strands by rolling them up on a pencil. (See Figures 3–21A and B.)

3–21A

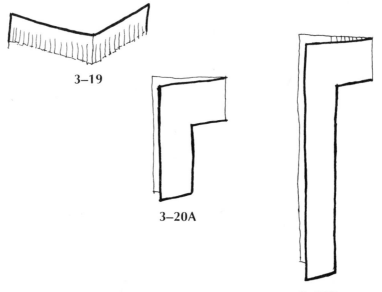

3–19

3–20A

3–20B

3–21B

Instructions for Wearing: With this "Ogre Mask," sight is restricted to what the child can see *under* the mask. While this may seem like unnecessary restricting of vision, this is not the case since the mask is worn at an angle, which allows ample vision for simple navigation.

OGRE MASKS

If there is anything a kid likes it's a *large* mask—and this one fills the bill!

YOU NEED:

> 18 × 24″ white or pastel construction paper (or two
> 12 × 18″ sheets glued together)
>
> (two) 4½ × 6″ construction paper to match the above
>
> crayons
>
> stapler
>
> glue (if needed)

TO PRESENT:

1. Simply have your kids draw a large face that fills or nearly fills the 18 × 24″ paper. The only qualifying restriction is this: that the top of the head remain rectangular in form. The 4½ × 6″ papers are used to make the ears, which are pasted to the head. (See Figure 3–22.)

2. When the head is complete and the chin is shaped, *your* job is to staple the back of the head into an End Cone.* The mask is now ready for spooking!

*See ART AND KIDS Glossary.

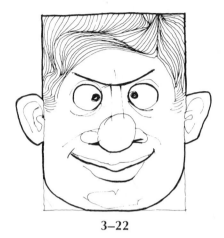

3-22

THANKSGIVING

4th Thursday in November

Although there were Indians such as Epenow of Martha's Vineyard who had been to England and back long before the Pilgrims ever thought of setting sail for the New World, the English have always enjoyed a better press!

Most kids, however, have very little real interest in the sober history of the Plymouth Colony; what they like is the turkey, the feast, and the pioneer trappings of the whole celebration. What kids are celebrating is not the triumph of the English over the Indians, but the spirit of the "Picnic in the Forest"; it is to this childhood version of the Pilgrim story that I have dedicated the following lessons.

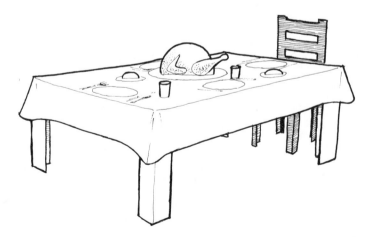

Lesson #6 The Harvest Table

All kids like to eat, and there is no better time than Thanksgiving to prepare this feast for the eyes!

YOU NEED:

> 12 × 18", 9" square, and 4½ × 3" brown construction paper
>
> 8½ × 11" duplicating, mimeograph or typing paper
>
> 9 × 6" manila drawing paper
>
> paste and crayons

TO PRESENT:

1. Have your kids make a "Sixteen-Part Box Fold"* with the 12 × 18" brown paper, and paste into a standard paper box. Set this box to one side to allow the paste to dry.

2. For each chair repeat the same Sixteen-Part Box Fold with the 9" square of brown paper, but rather than turning this into a box, cut away those sections indicated by the shaded lines in Figure 3–23. Save the cut-away pieces.

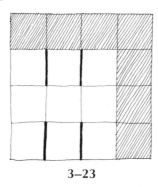

3–23

3. Cut on the heavy lines; fold up and paste into a box. (See Figures 3–24A and B.)

4. Using a three-square piece of the paper left over from Step #2, paste this piece in place to make the back of the chair. (See Figure 3–25.) If fancier chairs are desired, have your kids cut and trim their chairs much as the table legs are trimmed in Step #5. (Also see the lead illustration.)

5. By this time, the table should be dry. Cut as shown in Figure 3–26 to make the table legs.

3–24A

3–24B

*See *ART AND KIDS* Glossary.

3–25

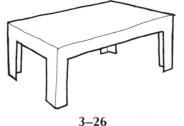

3–26

6. The white paper can then be pasted to the top of the table to become the tablecloth, or the table can be left bare. The manila paper is used to make the plates, dishes, etc. (See the lead illustration.)

Additional Suggestions: Since somebody always asks, "How do you draw a turkey for the table?" it might be a good idea to have a ready answer. While there is no *one* way to draw anything, here is the quickest way I know of to put a turkey on your table!

PASTING TAB

3–27

1. Fold a portion of the 4½ × 3″ brown paper lengthwise as shown in Figure 3–27. Unfold.

2. Draw a rough semicircle touching the fold, as shown in Figure 3–28.

3. Add the wing and the drumstick. Cut away the shaded area as shown in Figure 3–29A. Cut out a paper plate, fold the tab under and paste it to the plate! (See Figure 3–29B.)

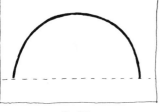

3–28

3–29A

3–29B

Lesson #7 Dressing Your Pilgrims

If your kids are going to celebrate Thanksgiving in the classroom, they might just as well dress for the occasion!

CAPS FOR THE LADIES

YOU NEED:

construction paper:

> 12″ squares of Pilgrim colors (browns, blues, and greens)
>
> 2 × 12″ white
>
> stapler
>
> paste and scissors
>
> bobby pin

TO PRESENT:

1. The 12″ Pilgrim Hat paper is folded in half and then half again. Cut off the shaded portion. (See Figure 3–30.)

2. Paste the white trim to one of the long edges of the Hat paper and make a series of cuts on the other. (See Figure 3–31.) Fold up on these cuts, fit to the head, and staple. Keep in place with a bobby pin!

3–30 3–31

HATS FOR THE MEN

YOU NEED:

> 6 × 24″ or 6 × 18″ and 6 × 6″ blue, green, or brown construction paper with matching 12″ squares
>
> 12″ (shy) circle pattern

3½" (watercup size) circle pattern

3 × 24" or 3 × 18" and 3 × 9" black construction paper

3" square white drawing or construction paper

large stapler

paste, pencil and scissors

TO PRESENT:

1. Basically, there is very little difference between the construction of a hat for a Pilgrim Father and one for Uncle Sam. (See "An Uncle Sam Hat," p. 136.) The only difference is in the addition of a hat buckle.

3–32

2. To make the buckle, fold the white paper in half and cut out the shaded area as shown in Figure 3–32. Open up and paste!

Assessories:

COLLARS FOR EVERYONE

YOU NEED:

12 × 18" white drawing or construction paper

scissors

cellophane or masking tape

3–33A

TO PRESENT:

1. Have your kids fold the white paper in half widthwise and cut out a semicircular opening on the fold side. Open up and cut on the heavy line. (See Figure 3–33A and B.)

2. Place the collar on the pilgrim and fasten at the rear with a small piece of tape!

BUCKLES FOR EVERYONE

YOU NEED:

3" squares of white drawing or construction paper

cellophane or masking tape

3–33B

TO PRESENT:

The buckles are to be cut out as explained in the Pilgrim Hat lesson above. Simply have your kids fasten the buckles to their shoes and belts with tape!

CUFFS FOR EVERYONE

YOU NEED:

 4 × 9″ white paper
 paper clips

TO MAKE:

 Simply have your kids wrap the white papers around their wrists and fasten with paper clips.

Final Suggestions

 Girls: If you are planning a full-dress "Pilgrim Day," suggest to the girls that, if they have them, long skirts and long-sleeved blouses would be ideal. In any case, a piece of white paper pinned to the front of their dresses would make a suitable apron.

 Boys: Long-sleeve shirts or jerseys are in order for the "men." For the final, perfect touch, have this crowd roll up their trouser legs to recreate the illusion of Pilgrim-style knickers!

WINTER

December 21 or 22 to March 21

The trouble with first day of Winter is that it arrives at just the wrong time. The best we can do for winter at this point is to give it a quick salute and get back to the Christmas scene!

Lesson #8 Winter Bears

If the squirrel is the symbol of Autumn then what better symbol for Winter than the hibernating bear?

Every time I show kids "how to draw" I always stress the point that what I am showing them is only *one* approach to drawing; if after trying it my way they would sooner do it their way—so much the better. In this approach I feel that I have covered all the bases: I have given a schema to those who would otherwise flounder, and I have shown the more inventive members of the class how others think without cramping their own, highly personal styles!

YOU NEED:

 practice paper
 drawing paper
 pencil and crayons

TO PRESENT:

1. A rectangle about the size of a square and a half is a good beginning point for these "square bears." Figures 3–34A, B, and C show how easy it is to turn this rectangle into a bear!

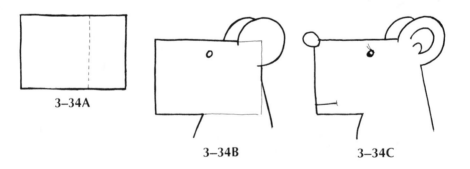

3–34A

3–34B

3–34C

2. Older kids may appreciate a few refinements: see Figures 3–5A and B.

3. As the for the bear's body, I just make my bears fat and put them in their pajamas. (See Figures 3–36 and the lead illustration.)

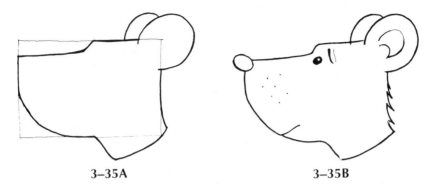

3–35A 3–35B

4. And that's that. Pass out the drawing paper and explain that this is what this lesson is all about: it's a salute to the bear's long winter nap!

3–36

Additional Suggestions: If your schedule is too busy to include this lesson in your pre-Christmas festivities, place a bookmark here inscribed with the words, "Wake me up in March." Then use this same lesson as a toast to winter's end!

CHRISTMAS

December 25th

In Christian countries, no holiday season is filled with as many emotional and sentimental memories as Christmas. But while Christmas is intended to celebrate the birth of Christ, the law is quite clear on the separation of church and state. Some day, I am sure, someone will succeed in forcing Christmas out of our schools, but in the meantime, I'll continue to celebrate it as I always have—with Santas and wreaths, Reindeer and holly, and with the sincere hope that the non-Christians among us will recognize my celebration for what it is—a gusty, midwinter salute to childhood.

Lesson #9 The Super-Wreath

There are any number of paper wreaths that will fill your Christmas needs, but I think you'll agree that this one is the best of all!

YOU NEED:

construction paper:

6 × 18″ green

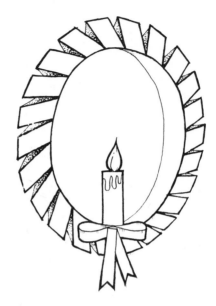

1⅛ × 6″ red

3 × ½″ white

paste, pencil, scissors and crayons

TO PRESENT:

1. Have your kids fold the green paper in half lengthwise, unfold, and then fold the long sides into the middle. (See Figures 3–37A and B.)

2. Refold on the center fold and on the folded side, draw lines as indicated in Figure 3–38. Cut on the heavy lines, and cut away the shaded portion.

3. Fold this green paper into a triangular tube and "test" it by holding an end in each hand and operating it as shown in Figure 3–39A, so that each cut opens on command. If the cuts are too short, the results will look something like Figure 3–39B, in which case the paper is unfolded and the short cuts lengthened.

4. When all is well, paste; then put paste on the bottom of the "tongue," insert this "tongue" into the "tail," and hold in place until the paste adheres. (See Figure 3–40.)

5. The small red piece is cut in half lengthwise. One of these halves is pasted first into a hoop, then into a bow. (See Figures 3–41A and B.) The other piece is folded in the middle with an askew fold (See Figure 3–42) and pasted to the back

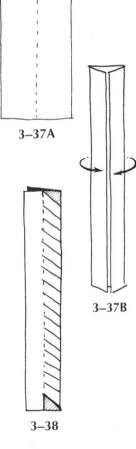

3–37A

3–37B

3–38

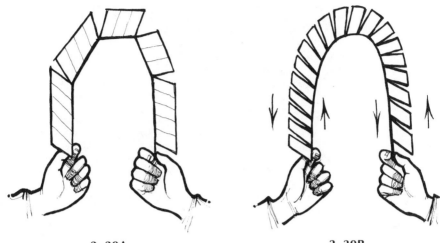

3–39A 3–39B

of the first piece to make a bow. The bow is then pasted to the bottom of the wreath.

 6. The white piece is folded at the bottom to make a pasting "foot," then it is pasted to stand upright on the inside of the wreath just above the bow. Add a "flame" from the scrap of yellow paper and Christmas is here! (See the lead illustration.)

3–40

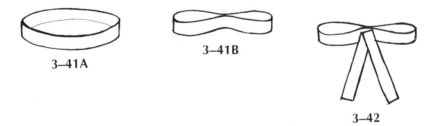

3–41A

3–41B

3–42

Lesson #10 Rudolph

 Little kids are always impressed with the ease with which a few simple pieces of cut paper can assume the shape of a living creature. "Rudolph" is that kind of a lesson:

YOU NEED:

 construction paper
 　12 × 18" black
 　1 × 18" white
 　brown: 3 × 9", 4½ × 6", and 3 × 4½"

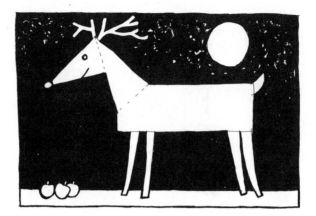

scrap red and yellow

white chalk

paste, pencil and scissors

TO PRESENT:

3–43

1. The hardest part of this lesson is the construction of "Rudolf's" head and neck, so let's begin there. Have your kids cut the smallest brown paper on the diagonal, then paste. Add an eye with the chalk, and paste his head to the $3 \times 9''$ body. (See Figure 3–43) six inch legs are cut from the $4\frac{1}{2} \times 6''$ brown paper and pasted to the body. Add a short tail from the left-over brown scrap, and a bright red nose from the red scrap. (See the lead illustration.)

2. After the long white piece has been pasted to the black "night" paper, have your kids paste on their "Rudolfs."

All that is needed now are a few final touches. The chalk is used to add the antlers (and possibly some snow flakes); the yellow scrap can be used to make a moon!

Lesson #11 An Old-Fashioned Folk Art Greeting Card

Of all my classroom Christmas cards, I like this one the best!

YOU NEED:

construction paper

$6 \times 9''$ white

$4 \times 5\frac{1}{2}$" light blue, dark blue, and yellow-green (or any other three colors that you think would make an effective card)

paste, pencil, scissors and crayons

TO PRESENT:

1. Have your kids fold the white paper in half widthwise to make the basic card. Set aside for later.

2. Have your kids fold one of the $4 \times 5\frac{1}{2}$" papers in half lengthwise, and draw half of a Christmas ornament against this fold. (See Figure 3–44A.) Cut out this ornament. While kept in this folded position, decorative cuts are then made as shown here. (See Figure 3–44B.)

3–44A

3. Unfold and paste this decorated ornament on another of the $4 \times 5\frac{1}{2}$" papers. Cut off the part of this second sheet that extends beyond the ornament.

3–44B

4. Paste this finished ornament onto the third sheet of $4 \times 5\frac{1}{2}$" paper, then paste this assembly on the front of the folded white card. *Merry Christmas!* (See the lead illustration.)

Further Suggestions: Once your kids get the idea, they can either make more of the same or use this idea to make decorative bell or tree forms! (See Figures 3–45A and B.)

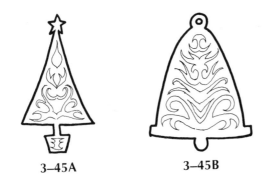

3–45A **3–45B**

HANUKKAH

As much as kids like to celebrate a holiday—any holiday—the public schools of this country have never given the Jewish holidays more than a token nod. In the case of Hanukkah, the reasons are many (and go well beyond the scope of this chapter), but two are important enough to warrant their inclusion here.

First of all, even among the Jews, Hanukkah is not considered a major festival. Secondly, ever since that fateful day when Moses destroyed the golden calf, ground it up into powder, scattered it across the water, and made the Israelites drink it (Exodus 32), the Jews have not been all that enthusiastic over the taste of representational imagery.

However, after a few false starts in trying to make Hanukkah compete with Christmas (does anyone here remember the "Hanukkah bushes" of the 1950's?*), there does seem to be increasing evidence in support of the idea that Hanukkah may yet achieve the popular success that the Irish have won with their St. Patrick's Day; for there are many who strongly feel that we *need* an open door festivity that celebrates all things Jewish, and Hanukkah is as good a time as any!

Throw in a Hava Nagila and I'll dance to that!

In the meantime, here are a couple of easy ones to practice on:

Lesson #12 A Star of David

The "Star of David" is easy to make and fun to do. Here are basic star-making instructions, followed by a much more elaborate "Graph-Paper Star."

BASIC STARS

Triangle Method: The easiest way to make a "Star of David" is simply to make two overlapping triangles. (See Figures 3–46A and B.) While little children enjoy this as a freehand exercise, older kids might prefer learning how to use the Compass Method to construct their stars from *perfect* equilateral triangles.

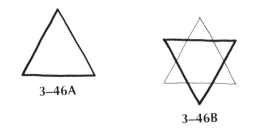

3–46A

3–46B

*Interestingly enough, since the "Christian" wreath is from imagery torn form the Old Testament, a "Hanukkah wreath" would not be as plagiaristic as it sounds!

Compass Method: This is the easiest method of all. Simply have your kids draw a circle with a compass, then use that same set radius to "walk" around the perimeter to mark off the six equal-distant points. (See Figure 3–47.)

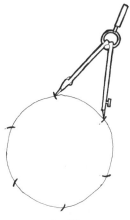

3–47

GRAPH-PAPER STARS

Although these stars are not geometrically perfect, few kids (if any) will ever know the difference. They're *fun* to do and, to many kids, *that's* what counts!

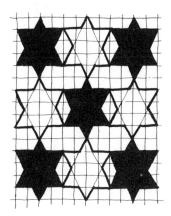

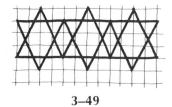

3–48

3–49

YOU NEED:

graph paper

pencil and crayons (or, even better, fine line markers)

1. Draw a row of tangent triangles four spaces high and four spaces wide. (See Figure 3–48.)
2. Overlap these triangles with inverted triangles of the same dimension. (See Figure 3–49.)
3. Continue constructing triangles in this fashion, until an all-over design pattern is created. Then decorate! (See the lead illustration)

Lesson #13 A One-Line Hanukkah Candelabrum

Hanukkah, the Feast of Lights, commemorates the triumph of the Maccabees over the Seleucids in 164 B.C. When the Maccabbes regained their desecrated temple in Jerusalem, they discovered only one day's supply of oil on hand for their candelabrum. But, a miracle took place and the oil lasted for eight

days, and since then candles have played an important role in the observance of this eight-day celebration.

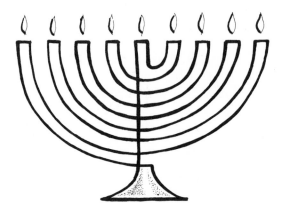

YOU NEED:

paper

crayons

TO PRESENT:

1. Have your kids draw nine equally-spaced dashes, as shown here in Figure 3–50.

3–50

2. Then, starting with the central dash, have your kids follow you through the fun maze of lines that are shown here. (See Figures 3–51A and B.)

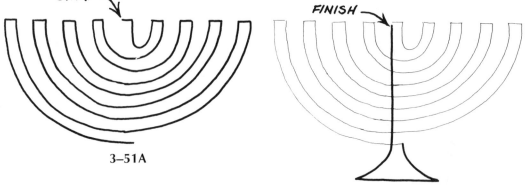

3–51A

3–51B

3. When they are done, have them draw in the candle flames and admire! (See the lead illustration.)

Further Hanukkah Suggestions: If the reader is seeking additional information and ideas for Hanukkah, I would strongly recommend Mae Shafter Rockland's *The Hanukkah Book* (New York: Schocken Books, 1975.)

NEW YEAR'S

January 1st

By New Year's the most exciting part of the school year is over; nothing between January and June will ever quite reach the same frenzy of excitement that was generated by Halloween and Christmas. To make matters worse, by the time that kids get back to school, the New Year celebration is about as exciting as last Wednesday's newspaper.

However—if you are clever enough, there *are* ways in which you can rekindle the New Year's spirit.

Lesson #14 Put a Baby in a Crib

The New Year's baby is as much a part of our occidental New Year's celebration as the dragon is to the Orient. I don't know about you, but I much prefer the baby.*

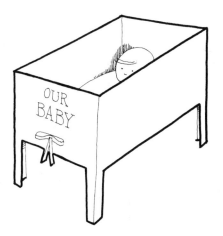

*Ever try to pin diapers on a dragon?

YOU NEED:

construction paper: 4½ × 6″ flesh-colored*
 (two) 12 × 18″ pink or blue
 4½ × 6″ pink or blue
 9 × 6″ white (two)
2½″ circle pattern
paste, pencil, scissors and crayons

TO PRESENT:

1. "Pink is for girls; blue is for boys." Pass out the large construction paper accordingly. (Two sheets each.) These papers are then folded into Sixteen-Part Boxes. (See p. 217.)

2. In order to arrive at a baby whose proportions fit the crib, begin by having your kids trace the 2½″ circle pattern on the flesh-colored paper.

Instructions for Drawing Children: Once the circle has been drawn, it is time to educate your class to the secret of drawing a child's face. Have your kids place the eyes and the ears lower than half-way down the face of the circle and a childlike face emerges naturally. (See Figures 3–52A and B.)

When your drawing lesson is over, have your kids transform the traced circle into a child's face, then cut it out.

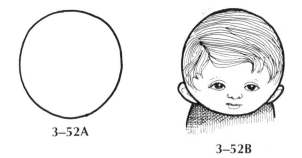

3–52A

3–52B

3. The smaller pink or blue paper is used to draw the babies' bodies snug inside their sleepers. Leftover scraps from the flesh-colored paper can be used for making hands. (See Figure (3–53.) Assemble and paste.

*See ART AND KIDS Glossary.

4. Now that the boxes constructed in Step One have had ample time to dry, they are pasted together, back to back, and trimmed to make a suitable crib. (See the lead illustration.)

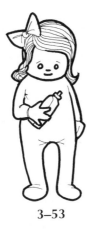

3–53

5. One of the white papers then becomes the bottom sheet, the other the top. "Turn down" the top sheet and your baby's bed is ready!

4

Seasons, Holidays, and Kids: The Final Stretch

MID-WINTER CELEBRATION

If the World Federation of Holiday Lovers were to present me with the honored task of improving our calendar, one of the first places I would begin would be on the barren stretch of uncelebrated days that stretch from January 2 to Lincoln's Birthday. As a matter of fact, I see no real reason why we shouldn't reschedule the First Day of Winter for the first Monday following the New Year; for what better time than this to raise our snow shovels in salute to Old Man Winter!

Lesson #1 The World's Largest Snowman

Anyone can draw a snowman, and for this reason, snowmen (or snowwomen) pictures are usually as banal as yesterday's classroom jokes. Here is a snowman lesson, however, that is inspired, and all it took to make this transformation of the hackneyed into a creative challenge was an imaginative change of scale!

YOU NEED:

12 × 18" gray drawing or construction paper
white chalk
pencil and crayons

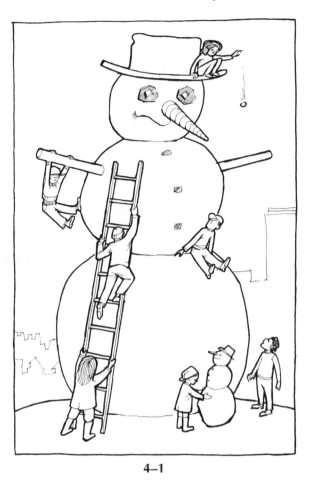

4–1

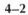

4–2

TO PRESENT:

1. Discuss with your kids the basic, three-circle snowman. Discuss hats, eyes, buttons, broomstick arms, etc. Once the review is complete, have your kids draw a *large* snowman and color it with white chalk. Then add a ground line. (*See* Figure 4–2.)

2. Once they have reached this stage in their picture making, apologize for "forgetting" to inform them of one important detail; this is no ordinary snowman they have created—it is the world's tallest!

3. Now the fun begins, for a snowman this big cannot be built without ladders to reach the top. Once your kids get the message that this is a "fun" lesson, they'll have that snowman crawling with kids within minutes! (*See* the lead illustration.)

If your classes respond to this lesson like mine do, you'll treasure this plan as one of winter's best!

Lesson #2 Connecting Snow Pictures

Here are two novel ways to greet a snowstorm* and both contain a lively, sputtering, long-fused surprise that will transform each individual contribution into an exciting, cooperative panorama!

NEIGHBORING HILLS

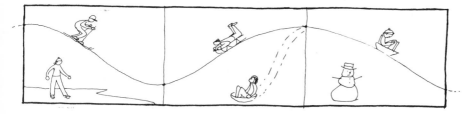

YOU NEED:

12 × 18" light blue (or gray) paper

chalk

crayons

PREPARATION:

Prepare a sheet of 12" × 18" light blue or gray paper with two penciled dots as shown here. Using this "master" as your guide, place identical dots on all of the remaining 12" × 18" papers. (See Figure 4–3.)

4–3

**Suggestions for Teachers Who Live in Snowless Areas.* The following lessons are easily adapted to other climes, so don't overlook these pages just because they are beginning to look like Yankee country. Simply replace the snow hills with green hills and dales, and revise your instructions accordingly!

Divide the prepared papers into two piles. On the top edge of the papers in the first pile, place a "T" for "top" as shown in Figure 4–4. Reverse the polarity of the papers in the other pile and place a "T" on the "top" edge of the papers in this pile. (See Figure 4–5.)

Giving one paper from the first pile to the first student, one paper from the second pile to the second student and so on, distribute these papers evenly throughout your classroom.

4–4

4–5

TO PRESENT:

1. Explain to your kids that, for reasons that will be announced later, their papers are all pre-marked, with little "T's" that mean "top." Keeping their "T's" at the top, they are instructed to search out the dots that are located on the left- and right-hand edges of their papers. Once found, these two dots are to be connected with a "hill" line. (See Figures 4–6A and B.)

4–6A

4–6B

2. Once the drawing supplies have been distributed and the hill lines drawn, your kids should have no difficulty transforming this hill into a child's paradise: kids skiing, sledding, building snowmen, etc. (See the lead illustration.)

The chalk, of course, is used to color in the snow and to add a cold cloud or two to the wintery sky.

3. The surprise comes when the kids discover (with or without promoting) that these pictures "hitch" together to form a long range of undulating hills that should stretch halfway around the room!

WINTER ROADS

YOU NEED:

12 × 18″ black construction paper

12 × 18″ white drawing or construction paper

paste, pencils, scissors, and crayons

PREPARATION:

Prepare one 12 × 18″ "Master" sheet as shown in Figure 4–7.

4–7

Using this master as your guide, transfer identical marks to all of the 12 × 18″ white papers.

TO PRESENT:

1. Explain to your kids that there are small penciled dots on each of the four edges of their white papers. Once they find these marks, explain that these dots represent the edges of roads that have been buried in the snow. Their jobs: to pencil in the outline of the missing roads. (The creative variations here are innumerable. Here are a few of the possible variations. (See Figures 4–8A, 4–8B, 4–8C.)

4–8A

4–8B

4–8C

2. Once the roads have been penciled in, have your kids turn these papers over to scribble-cancel* on the reverse side. Once the scribbling is complete, return the papers to their original position.

3. Now comes the part of this activity that needs strong directions. Explain very carefully to your kids that they are to cut on all lines to separate the snow areas from the roadway. Once this has been done, have them reassemble the pieces on the black paper. Then, simply paste down the "snow" and remove the "roadway."

4. From this point on, this art activity can take one of two directions:

 a. Using crayons, cut paper or other art materials, have your kids use these roads as a "starter" for a winter landscape.

 b. Or, using folded paper stand-ups, the landscape can become three-dimensional. (*See* Figure 4–9.)

Either way, the surprise comes when the kids discover that this network of roads interconnect in *all* directions. And *that's* when the real fun begins!

4–9

GROUND HOG DAY

February 2nd

The trouble with Ground Hog Day is that most of the kids in urban America have never seen a ground hog. This being the case, I would recommend that you join me in observing this day as if it were National Shadow Day! (See Introduction, p. 8.)

*See *ART AND KID'S* Glossary, p. 214.

LESSON #3 I Got *Own* Shadow

Shadows do not play a major role in the history of world art. The Orientals, the Persians, the pre-Renaissance artists* all ignored them; so it comes as no great surprise to learn that, for the most part, kids ignore them too! Here, however, is a lesson designed to bring the shadow into the spotlight!

YOU NEED:

12 × 18″ drawing paper
9 × 6″ drawing paper
9 × 6″ black construction paper
large stapler

*While there are no well-known ground hog artists, it can be readily assumed that ground hogs are all extremely shadow sensitive; otherwise why would they come out of their holes on February 2nd simply to determine whether or not their shadow has survived the winter?

TO PRESENT:

1. Have your kids draw a front-view person (preferably a portrait of themselves) on the 9 × 6″ drawing paper. Since this figure will eventually be cut out, be sure to stress the need for structural solidarity, particularly in the areas of the armpit and neck. (See Figure 4–10.)

4–10

2. Once the kids are hard at work, I generally begin stalking a dark corner of the room under the pretense that I am looking for something. Once the class begins to share my concern, I put *them* to work, in various parts of the room, to "help me find it." ("Find what?" "Don't ask, you'll know it when you see it!")

Eventually I go to another part of the room and with mock astonishment I announce that I have found "it." ("Found what?") My shadow!*

At that, I shepherd the kids to the sunlit part of the room so that they can study their own shadows. The main point being, of course, that shadows live terrible lives because, most of the time, there is someone standing on their feet!

*Although this script would never make it on Broadway, you're not teaching adults; and with kids, this mini-play makes for a dramatic interlude with a humorous ending!

3. Once the kids are back in their seats, use a Temporary Staple* or two to pin their drawings to the black "shadow" paper. Once pinned, the drawings are cut out through this double thickness of paper.

4. Once the drawing and the shadow have been cut out and the staple removed, paste the feet of the person to the top of the shadow's feet. Then paste both to the large drawing paper.

5. At this point, a lay person might think the lesson was over; all that is needed is for the teacher to retire and let the kids finish up. What need be remembered here is that the problem seriously fractures a child's conception of what a picture should be. In other words: how can you include a ground line at the base of the paper, for if you do, only the shadow's head will be touching the ground, while the figure will be left suspended "up in the sky"!

This being the case, the teacher must step in to explain that there are many ways of "seeing" the world, and the groundline or baseline approach is but one way. Many adults, you explain, like their pictures with the ground line raised. A few illustrations of what you are talking about—even with little children—is all they need to orient themselves to this "new" way of thinking. *Then,* let them go back to work. Now your job is over!

LINCOLN'S BIRTHDAY

February 12

By and large, the most successful of the various child-centered holidays are those that offer food or gifts. Secondary calendar events seem to succeed either by virtue of an imaginative theme, or because they offer release-time from school. And then there are *those* "holidays," like Lincoln's Birthday, that offer none of the above.

So, if you really want to celebrate Lincoln's Birthday in a memorable way, you are going to have to do something BIG. This being the case, why not do the logical thing and hold a good old-fashioned eat and drink classroom party in his honor?

*See *ART AND KIDS* Glossary, p. 218.

But a party celebrating what? What is it in Old Abe that deserves all this attention? What do we salute? His height? His beard? His top hat? His celebrated silhouette? While there are some who would like to hold onto the myth that Lincoln conducted the Civil War to free the slaves, this idealized and oversimplified version of history involves too many complex issues to make for a feasible theme.

What *is* true is that Lincoln rose from a humble cabin heritage to become President of the United States.* And on this convenient half-truth, there is a message worthy of any classroom celebration. Spread the word that, while not every poor boy and girl can and will succeed in life the way Abraham Lincoln did, no one—rich *or* poor—is going to succeed at all unless he or she tries.

So tell the Lincoln Story as the old-fashioned gospel according to Horatio Alger, and you will have transformed a simple calendar "observance" into the kind of a classroom event that a smiling Lincoln would have whole-heartedly endorsed!

LESSON #4 Lincoln Logs

*What isn't being said, of course, is that in yesteryear, just about everyone, rich *or* poor, lived in log cabins. But let your kids learn about *that* in somebody else's history course!

While I am not about to guarantee any great historical accuracy between my log cabin and the one in which Lincoln was born, my cabin is unquestionably easier and much more fun to build!

YOU NEED:

Construction paper:

6 × 11" gray or white

4½ × 12" black

½ × 12" brown

4½ × 6" red

12 × 18" manila drawing paper

Paste, pencil, scissors, and crayons

TO PRESENT:

1. After telling your class the story of Abraham's childhood, pass out the 6 × 11" house paper and six to eight brown ½ × 12" log papers. Have your kids lightly pencil in the door and windows before decorating the fronts of their cabins with log and "clay" exterior (the clay effect is done by letting a thin line of the "house" paper show between the logs).

2. The basic house is then pasted onto the 12 × 18" manila drawing paper in such a way as to allow room for the black roof.

3. Have the roof overlap the top of the cabin and then, for a special three-dimensional effect, suggest to your kids that they curl the lower edge of the roof slightly, so that it will extend out from the log foundation.

4. The window and the interior, as seen through the open doorway, are to be finished as the kids want. From the remaining piece of red paper, a door and a chimney can be added as shown in the lead illustration. Add an appropriate background and you have a house fit for a president!

WASHINGTON'S HOLIDAY

3rd Monday in February

Nobody except the merchants who hold their annual !!! WASHINGTON'S BIRTHDAY SALES !!! seem to know how

to celebrate this presidential holiday. Certainly, we can't expect our classes to chop down a cherry tree, or to throw a silver dollar across the Potomac, so what do we do? To kids (and to many adults as well) the War of Independence is so distant and so remote that nowadays it's difficult to even work up a lather against the British!

Here, however, are two Washington activities that will help you along with your celebration: the first being instructions for a three-cornered "George Washington Hat," and the second a powdered head to put it on!

Lesson #5 A George Washington Hat in Miniature

By itself, this lesson is a simple do-as-I-do activity: a clever bit of paper folding. It can be used as an end in itself, as an individual popcorn or candy dish for your George Washington party, or as a hat for the lesson that follows!

YOU NEED:

6" square of blue construction paper

paste and scissors

TO PRESENT:

1. Have your kids fold the blue paper according to the instructions given for the "Sixteen-Part Box Fold."*

2. Fold on the diagonals and cut on the heavy line as shown here in Figure 4–11.

4–11

*See *ART AND KIDS* Glossary.

3. With that the work is done; the paper is simply folded up and pasted into a three-cornered hat! (See Figures 4–12A and B).

4–12A

4–12B

Lesson #6 A George Washington Hat on a George Washington Head

YOU NEED:

 9 × 12″ manila

 "George Washington Hat in Miniature" (See previous lesson)

 white chalk

 paste, pencil, scissors, and crayons

TO PRESENT:

1. Have your kids fold their 9 × 12″ paper in half and then again into quarters. (See Figure 4–13.)

2. Fold this same paper in half lengthwise, and fold one of the long sides in to touch the middle fold. (See Figure 4–14.)

3. Place X's in the boxes indicated in Figure 4–15, and cut away the shaded areas.

4–13

4–14

4. After the paper has been refolded on the center fold, have your kids draw Washington's profile something like the one shown in Figure 4–16. The parts indicated by shading and the underline of the chin are to be cut away through the folded sheet.

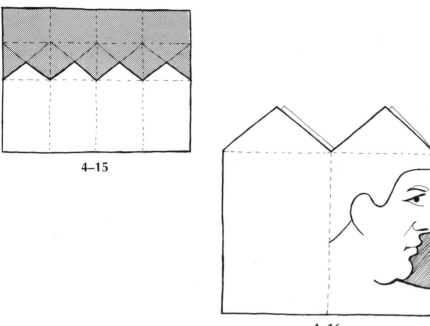

4–15

4–16

5. The other side of the face is then completed* and the back of the head is indicated on *one* of the side flaps. "Powder" the wig with white chalk. (See Figure 4–17.)

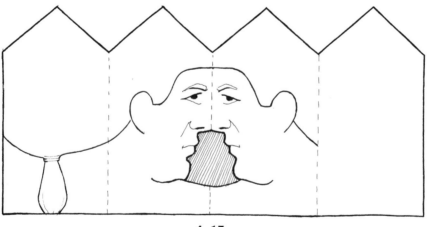

4–17

*The easiest way to accomplish this is to refold the paper on the center fold, so that the two sides of the face are in contact with each other, then transfer the image by rubbing on the reverse side of the drawing with a hard object such as a steel scissors handle, the reverse end of a plastic pen, etc.

6. Fold up and paste into a triangular stand-up. Add the hat from the previous lesson and your classroom army is assembled to celebrate your Washington's Birthday party!

VALENTINE'S DAY
February 14th

If an interest in the opposite sex has anything at all to do with Valentine's Day, how do you explain the perennial, high-pitched excitement that this day generates in *young* children? Are kids interested in romance? Certainly a Martian anthropologist studying our children and watching the voluntary segregation that takes place on the playground, in the cafeteria and in the streets would soon arrive at just the opposite conclusion. And yet, how do you explain—even to yourself—why it is the *young* children, the six- to ten-year-olds, who obviously enjoy this day most of all?

Sigmund Freud, where are you?

Lesson #7 An Introduction to the Pop-Up

Even though they know what's coming, kids love the repeatable "surprise." Find a way to wed this love of the unexpected to the excitement of Valentine's Day, and you'll produce a child-winning lesson plan every time! One of the best ways I have found to insure this kind of success is through the use of the *pop-up*. Here, in the pages to follow, are the basic, bare-bones instructions for three of my favorite pop-up mechanisms. And after you understand the mechanics involved, turn quickly to Lessons 8, 9, 10, and 11.

A-POPS

YOU NEED:

one large sheet of construction paper

one smaller rectangular sheet of construction paper

TO MAKE:

1. Fold the large sheet in half widthwise and set aside for later.

2. Fold the smaller sheet as shown here: first in half, then fold each half back upon itself to touch the first fold. (See Figures 4–18A, B and C.)

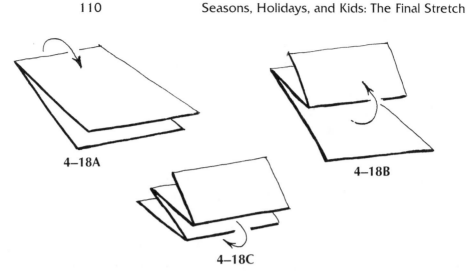

4–18A

4–18B

4–18C

3. Paste *one* end of this accordion-pleated paper to the larger paper as shown in Figure 4–19.

4–19

4. Add paste to the other end of this accordion-pleated paper. Close the "cover" of the larger paper and press for a second or two.

5. Reopen the "book" and *presto*! Your basic A-POP appears with a magic all its own! (See Figure 4–20.)

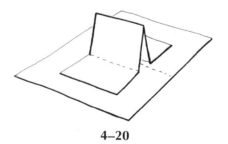

4–20

TRI-POPS

YOU NEED:

A rectangular sheet of construction paper

A triangular sheet of construction paper made from the diagonal of a square. (The base of the triangle must be equal to or shorter than the length of the first (rectangular) sheet.

TO MAKE:

1. Fold the rectangular sheet in half widthwise and set aside for later.

2. Fold the triangular sheet in half. (*See* Figure 4–21A.) Unfold and position so that the "hump" of the fold is uppermost. (See Figure 4–21B.) Fold up each of the 45 degree corners so that they touch the apex of the triangle. (See Figure 4–21C.)

3. Put paste under the 45 degree corners and position onto the larger sheet so that each of their respective centerfolds coincides. (See Figure 4–22.)

4. The completed pop will then fold flat when the outside paper is closed, and spring open when unfolded. *Voila!* (See Figure 4–23.)

5. Now turn to lesson 10.

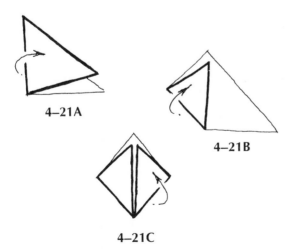

4–21A

4–21B

4–21C

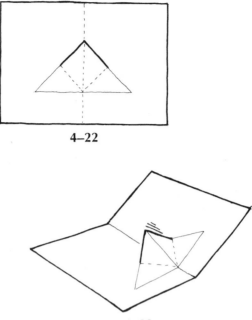

4–22

4–23

Y-POPS

YOU NEED:

> one large sheet of construction paper
> one smaller sheet of construction paper

TO MAKE:

4–24

1. Fold the larger paper in half widthwise and set aside for later.

2. Fold the smaller paper into quarters, and cut on one of the long folds as shown here in Figure 4–24.

3. Paste one of the "legs" of this smaller paper to the larger paper in such a way that the inside top corner of this leg touches the center fold of the larger paper. (See Figure 4–25A.) Following the natural order of the folds, fold up this paper and add paste to the other "leg." (See Figure 4–25B.) Fold over the free side of the larger paper on top of the pasted surface and press to adhere.

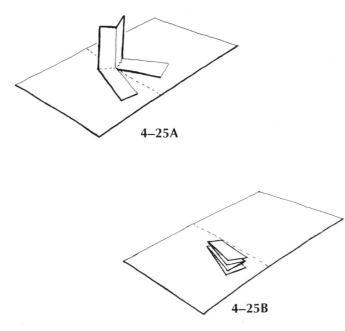

4–25A

4–25B

4. Open the folded paper and presto again! Another easy-to-make and highly efficient pop-up.

5. Now turn to Lesson #11.

Lesson #8 A Head Start for Valentine's Day

Here is a simple, easy-to-make Valentine that is definitely a child pleaser!

YOU NEED:

red construction paper in the following sizes:
 $6 \times 18''$ and $3 \times 12''$
6'' square drawing paper
5½'' square white drawing paper

TO PRESENT:

1. Have your kids fold their $6 \times 18''$ red sheets width-wise; set these aside for later.

2. The other red sheet is folded into an A-Pop (See p. 109) mechanism and pasted fairly close to the center fold of the red sheet. (See Figure 4–20 again.)

3. Invite your kids to draw some kind of a silly face on a 6'' square and paste it to one of the upright sides of the pop-up. After a message has been written on the 5½'' square and this square is pasted into position (see the lead illustration), this looney-style greeting card is ready to go!

Additional Suggestions: And if classtime permits, have enough extra paper on hand to allow your kids the makings for a cover decoration. (No further instructions necessary!)

Lesson #9 Animal Pop-Ups

At one time or another I have used the A-Pop mechanism for all kinds of crazy "Animal Pop-Ups." Here is one of my favorites.

A VALENTINE DOG

YOU NEED:

red construction paper:

9 × 12″ and (two) 5¼ × 9″

dog-colored* construction paper:

6 × 9″ and 3 × 4½″

plus assorted scraps of red, white, and other pieces of
 construction paper to be used for decorating

paste, pencil, scissors, and crayons

TO PRESENT:

1. The 9 × 12″ red is folded in half widthwise and then
set aside for later.

2. The larger of the "dog" papers is folded in half width-
wise, then folded once again on the "open" side of the paper
to make two pasting tabs. (*See* Figure 4–26.)

4–26

3. The basic proportions of a dog are then sketched in the
area indicated in Figure 4–27, care being taken to retain the
fold line as the back of the dog. The shaded areas are then cut
away.

4. The smaller dog paper is folded widthwise to form the
"head" paper. Draw a head in the area indicated in Figure 4–
28A, taking care to retain the fold line that makes up the back
of the neck. The shaded area is then cut out and the dog's
head is pasted straddle-like over the body of the dog as shown
in Figure 4–28B. Ears are cut from a scrap of contrasting "dog
color" construction paper and pasted into place.

5. It is now time to assemble the parts: paste is placed
along the short ends of the 9 × 12″ red paper and the 5½ ×

*By *dog-colored paper* I mean, of course, any color of construction pa-
per that would approximate the coloring of a dog (brown, black, gray, or
white).

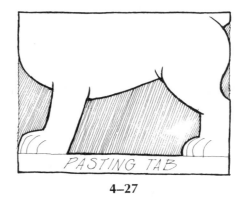

4–27

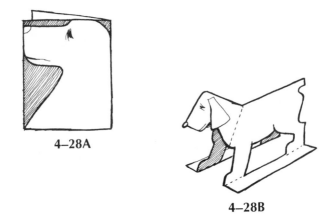

4–28A

4–28B

9" pieces are positioned on top. (See Figure 4–29.) Next, the base flaps of the dog are turned out, slid under the long, un-pasted edges of the 5¼ × 9" pieces and then pasted into po-sition to make an elaborate "A-Pop" mechanism.

6. From here on the project is turned over entirely to the kids. They can decorate inside and out to their heart's content!

4–29

Lesson #10 Hearts A'Poppin'

Here are two ways to put your "Tri-Pop" mechanism to effective use!

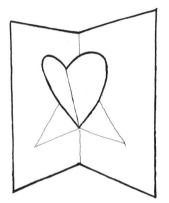

A SIMPLE TRI-POP VALENTINE

YOU NEED:

red construction paper:

9 × 12"

6 × 6 × 8½" triangle (one half of a 6" square)

4½ × 6" white drawing or construction paper

odds and ends of red and white decorating paper

paste, pencils, scissors, and crayons

TO MAKE:

1. Have your kids fold the 9 × 12" paper in half width-wise. Set this paper aside for later.

2. The triangular piece is folded into a "Tri-Pop" mechanism and pasted into position. (See instructions on p. 111.)

3. A large white heart is then cut out of the white paper and pasted onto the central part of the "Tri-Pop" in such a way that the center folds are aligned. (See Figure 4–30.)

4. The basic valentine is now ready for action. Fold it and the heart will completely disappear. Open it and the heart jumps up. Invite your kids to decorate this valentine in any manner they choose. (You will not have to invite them twice!)

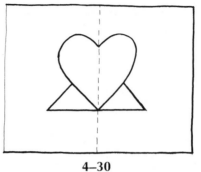

4–30

TRIPLE TRI-POPS

YOU NEED:

> red construction paper
>> 9 × 12"
>> 4½," 3" and 2¼" squares
>
> white drawing or construction paper:
>> 6 × 9"
>> 3 × 4½"
>> 3 × 2¼"
>> 1½" × 2½"
>
> odds and ends of red and white construction paper
> paste and scissors

TO PRESENT:

1. Begin by having your kids fold their 9 × 12" red paper in half widthwise.

2. The 6 × 9″ white paper is cut in half diagonally and pasted to the red paper as shown in Figure 4–31.

3. Each of the red squares are folded in half diagonally and cut on the fold. One of each size of the resulting triangles is then folded into a "Tri-Pop" (See instructions on page 111) and pasted as shown in the lead illustration.

4. Each of the white papers is folded lengthwise and made into white hearts. (See Figure 4–32.) The white hearts are then pasted into position as shown in the lead illustration. The basic Valentine is now ready for all kinds of personal and creative decorating touches!

4–31

4–32

Lesson #11 People Pop-Ups

One great idea for the "Y-Pop" mechanism (p. 112) is to use it as a people propellant!

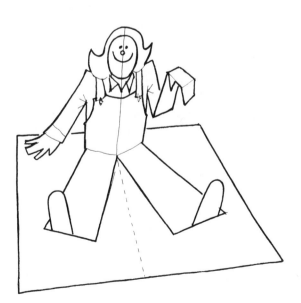

YOU NEED:

 9 × 12″ red construction paper

 9 × 12″ white drawing or construction paper

 odds and ends of red and white construction paper for
 decorating

 paste, pencil, scissors, and crayons

TO PRESENT:

 1. Fold the red paper in half widthwise and set aside for
later.

 2. The white paper is then folded into quarters and un-
folded. Tell your kids to draw a pencil line down one of the
long folds as indicated by the heavy line in Figure 4–33. This
line represents the line between the legs of the valentine char-
acter that will follow. (Sorry, no skirts!) Invite your kids to
make any kind of person (or creature) using this format, the
funnier the better. The only additional instructions are these:
whatever the figure, the wrists must fall on the lateral fold and
the feet must be drawn as if the figure is on tiptoes. (See Figure
4–34.)

4–33

4–34

3. Cut out the figure and position it as shown in the lead illustration—but do not have your kids paste it until they are familiar with the next step.

4. Once the figure is positioned *towards the top of the red paper* as shown above, have your kids paste one leg and one hand from the same side of the body to the supporting paper. (Do not paste the foot!) Then fold up the figure on top of the one pasted leg as shown in the "Y-Pop" lesson on page 112. When the accordion-like fold is complete, instruct your kids to add paste to the back of the other leg and hand, and carefully close the cover of the card to make contact with the pasted surface. Press—then open! Happy Valentine's Day!

Additional Suggestions: Rather than to paste the hands, one or both of the hands can be freed as shown in the lead illustration. Simply fold the arm at the elbow and let it do its own thing!

SAINT LEPRECHAUN'S DAY

March 17th

There is no reason in this world why St. Patrick's Day should assume the importance that it does. Most of us are not Irish, do not believe in the "little folk," and do not understand how a celebration in honor of this Welsh patron saint of Ireland ever became entangled with a carnival of gnomes. But whether we, as adults, "understand" the insanity of this day or not, our rational approach is foreign to all those things that make childhood fun.

Kids like leprechauns. They enjoy thinking about leprechauns, they enjoy hearing stories about leprechauns, and they enjoy any kind of art activity that puts these interests to work. And *that's* all the reasons we need to prepare a kelly green celebration in honor of all the "Little People" in this world.

Erin go Bragh: Childhood forever!

Lesson #12 Leprechaun Hats!

Sometimes all it takes to assure a successful art activity is a *starter*, a launching pad from which imaginations can be fired into orbit. Here is one of the best!

YOU NEED:

> 12 × 18″ drawing paper
>
> 4½ × 6″ green construction paper
>
> small scraps of white paper
>
> paste, pencil, eraser, scissors and crayons

TO PRESENT:

1. Have your kids begin by penciling an oval on the green paper as shown in Figure 4–35A. From each end of this oval, vertical lines are drawn. (Figure 4–35B.) A curved (or "sad" line) is then drawn to enclose the top. (See Figure 4–35C.) The hat is nearly finished when a larger oval is drawn around the first oval. (See Figure 4–35D.)

2. The lines indicated by dotted lines in Figure 4–36D are then erased. Once this erasure is made, have your kids darken up all the main lines with black crayon. To indicate the buckle that is half-hidden by the upturned hat brim, cut out a small inverted "U" from the small scrap of white paper and paste it into position. After adding that part of the hat band that would normally be visible, cut out the hat. (See Figure 4–36.)

3. Now comes the last step in the construction of this starter. Semicircles are then drawn at each end of the hat opening to represent the ears. Then, have your kids cut out that area indicated by the shading in Figure 4–37.

4. The finished started is then pasted onto the 12 × 18″ paper and the head of the "leprechaun" is drawn in. The rest of the figure (as well as the rest of the picture) is left totally to your kids! (See the lead illustration, page 121.)

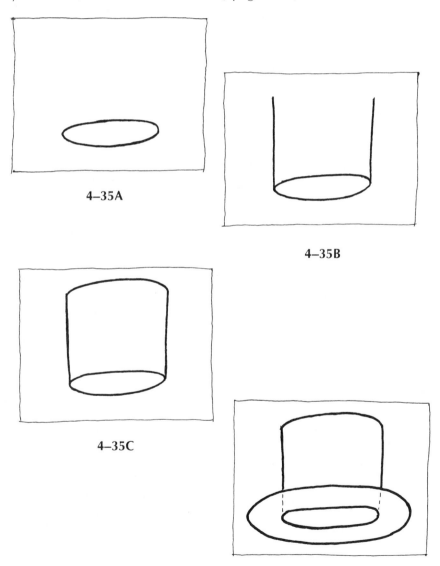

4–35A

4–35B

4–35C

4–35D

4–36 4–37

Additional Suggestions: I often have my classes make two "Leprechaun Hat" starters, and find that the resulting pictures are well worth the additional effort.

SPRING

Usually March 21 to June 21

Unlike the adults who see winter as an endless expanse of unpaid heating bills, kids love winter and all it stands for. But as much as they look forward to the first snowflake, few tears are shed when the old, yellow, curbside snowdrifts begin their last melt-down. When Spring comes, kids are ready to leave winter behind, and so am I—as you can tell from this lively selection of up-beat, springtime lesson plans!

Lesson #13 Spring Birds!

As the Squirrel is to Autumn (see page 60) and the Bear to Winter (see page 80), so is the Bird to Spring. While my

"Spring Birds!" differ in some respects from the usual run of birds, I assure you that your kids will be the first to applaud the difference!

YOU NEED:

 practice paper
 drawing paper
 pencils and crayons

TO PRESENT:

Preliminary Practice: Using nothing more than a pencil and a piece of practice paper, have your kids follow these few simple *starter* steps.

1. To draw the beak: begin with a lazy "V" and follow the steps shown in Figures 4–38A, B, C, D and E.

2. The rest is easy. Invite your kids to complete the head, and add a body supported by skinny bird-legs as shown in the lead illustration. Be sure to suggest sneakers for some of your birds—and your kids will be happy to respond in kind!

4–38A

4–38B

4–38C

4–38D

4–38E

APRIL FOOL'S DAY

April 1st

Since it is totally ignored by our state and federal government, April Fool's Day is not really a holiday at all, but who cares? Kids celebrate it and that's who this book is all about!

Lesson #14 Make an April Fool

All artwork worthy of the name was done by someone who *cared*, and caring can embrace humor as well as more stereotyped or conventional forms of "beauty." That comedy is a serious business is a point that this lesson drives home with vigor, for the best results in this lesson will invariably come

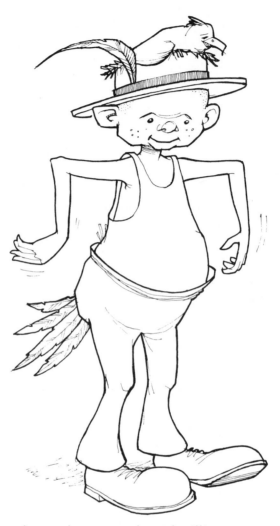

from those who are ready and willing to expend the most energy making a fool *from* themselves!

YOU NEED:

 drawing paper

 crayons

TO PRESENT:

 1. Try to explain, in elementary language, the message contained in the previous paragraph. Explain to your kids that the comedy they see on television, in the movies, or on the

stage isn't extemporanious silliness. It's carefully planned and executed.

2. Once this prologue is out of the way, pass out drawing paper and art materials and tell your kids that it is their job to produce the funniest "April Fool" that they can invent!

3. Then—stand back and let your little "fools" go to work!

ARBOR DAY

There has always been a need for a tree-centered day, but for kids Arbor Day has its problems. First of all it is not a national holiday and, in fact, is not even a "day" at all, since it is celebrated at different times in different states.* But where Arbor Day is most obviously deficient is in its lack of the child-catering zaniness that makes holidays fun. So until that day, when one or another of us decides to invent a more imaginative mythology, I guess we will just have to celebrate this event in our own way—and keep on drawing trees!

Lesson #15 Three Ways of Drawing Trees

Did you ever take a close look at the trees kids draw? (See Figure 4–39.)

Most trees drawn by children have enormous trunks, squatty, ovoid foliage, and bright red apples. (The childhood apple tree is a specie of evergreen, for it is decorated with apples all winter long!)

So, instead of planting childhood apple trees this Arbor Day, it might be fun to investigate a whole grove of alternate approaches:

YOU NEED:

practice paper

drawing paper

pencils and crayons

Preliminary Instructions (to be done on the practice paper)

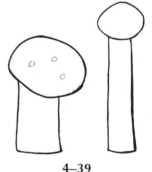

4–39

*Arbor Day is not celebrated at all in Alaska.

Icicle Trees

1. Have your kids use their black crayons to draw an upside down "icicle." (See Figure 4–40A.) To this main body of the tree, have them add icicle-shaped limbs. (See Figure 4–40B.) The only rule that must be emphasized here is that the base of the limbs must be smaller than that part of the tree from which it is sprouting! And continuing in the same spirit, let the branches sprout forth from the limbs. (See Figure 4–40 C and D.)

2. Once the basic tree is done, the foliage is colored in and the tree is complete! (Apples are optional.) (See Figure 4–41.)

4–40A

4–40B

4–40C

4–40D

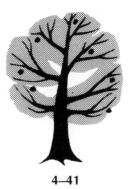

4–41

M and W Trees

1. The "M and W Tree" begins as in Step One of the "Icicle Tree." (See above.)

2. It is in the foliage, however, that the "M and W Tree" earns its name. This is a trick that was well-known among the old masters: simply draw your leaves as squiggles of m's and w's! (See Figure 4–42.)

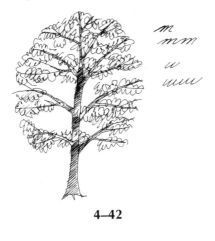

4–42

4–43

Other Trees

"Hand Trees": Earlier in this book, I showed you how to make "Hand Trees." (See page 45.) "Hand Trees" can also sprout "M and W" leaves as shown here in Figure 4–43.

"Sponge Trees": For Sponge Tree ideas, see page 200.

"Pine Trees": There are many ways to indicate pine trees. Here are a few! (See Figure 4–44 A and B.)

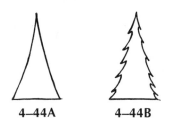

4–44A 4–44B

TO PRESENT:

After such a lengthly preliminary instruction period, the kids should have enough ideas of their own as how to incorporate trees into their pictures. They have listened to you long enough—now let them go to work!

EASTER

Easter is another zany time of year. What do the Easter Bunny and all his eggs have to do with the Resurrection of Christ? Nothing. The Easter Bunny, Santa Claus, and the leprechauns all share one thing in common: they are the uninvited guests who turn out to be the life of the party!

Lesson #16 A Basket for a Hungry Rabbit

I have spent a good part of my life devising art lessons and inventing novel art activities, and here is one of my Easter best! I'm proud of it and I think you will soon see why!

YOU NEED:

construction paper:
 12" square white
 3 × 4½" green (4 each)
 4½ × 6" green

$3 \times 18''$ yellow, yellow-orange, or orange

assorted scraps

an orange crayon

plenty of staplers

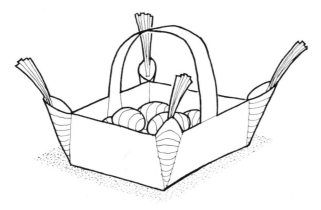

TO PRESENT:

1. Have your kids fold the 12″ square of white drawing or construction paper into 16 parts. (See the "Sixteen Part Box Fold" in the *ART AND KINDS* Glossary.) Color all four corners with an orange crayon. (See Figure 4–45.)

4–45

4–46A

4–46B

2. Each of the green papers is then fringed as shown in Figures 4–46A and B, and folded up to make a "carrot top."

3. Have your kids turn their white papers over to staple these "carrot tops" to the reverse side of the orange squares, as shown in Figure 4–47.

4. *Your* job is to staple the basket together, as shown in the lead illustration, in order to complete the illusion of a basket graced with four decorative carrots!

5. The $3 \times 18''$ handle is folded in half lengthwise, then stapled on when ready. The Easter grass is made by cutting thin strips of the $6 \times 9''$ green paper, wrinkling it, and placing it in the basket. Scraps of colored paper can then be used for making paper eggs. (But by this time, further suggestions will probably be unnecessary!)

4–47

Lesson #17 Funny Bunnies

Artists are quick to draw a sharp distinction between representational creatures and "funny animals." Since *real* rabbits do not walk around on two legs, carry baskets, or paint eggs, those who do are accordingly dubbed "Funny Bunnies." But, just because these comic creatures do not have real life counterparts, does not mean that they should be either ignored or belittled, for these Bunnies play a central role in a child's Easter Celebration!

YOU NEED:

$12 \times 18''$ assorted pastel construction paper

$6 \times 9''$ white drawing or construction paper (3 sheets)

3½" circle patterns (watercup size)

paste, pencil, scissors and crayons

TO PRESENT:

1. Discuss with your kids the differences between "real"
rabbits and Easter Bunnies. Explain that, since the Easter Rab-
bit is not a "real" rabbit, the whole subject is open to imagi-
native interpretation. Here, in Figure 4–48A, B and C) are a
few suggestions for drawing the head.

simple face

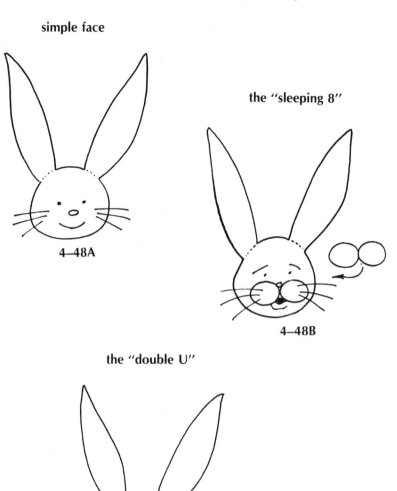

the "sleeping 8"

4–48A

4–48B

the "double U"

4–48C

2. Have your kids trace the circle pattern at the bottom of one of the sheets of white paper. Add ears. (See Figure 4–49.) Since this is a white rabbit, color the inner part of the ears pink. Cut out this incomplete bunny head. Once the head has been cut out, have your kids make a cut in the bottom of the head as indicated here by a heavy line. Decorate the top of the cut with a pink nose, and then add eyes.

4–49

3. Show your kids how the two adjoining sides of the cut are to be overlapped and pasted, Circlecone style,* to form a "stick out" nose. Then, once this section has been pasted, let the kids add the mouth in their own way. (See suggestions in Step 1 above.)

4. The ears to this rabbit are then pasted to the $12 \times 18''$ paper. Another $6 \times 9''$ white paper is used to draw a bunny-like body with large bunny-like feet. (See Figure 4–50.)

5. The third sheet of $6 \times 9''$ white paper is a "just in case" optional to be used, if needed, for additional details. (Many will want to make decorated eggs with this paper.) Otherwise, your job is over. Just turn your kids loose and let them continue with this Easter celebration in their own way!

4–50

*See *ART AND KIDS* Glossary.

OUR PATRIOTIC HOLIDAYS

Armed Forces Day, 3rd Saturday in May
Memorial Day, last Monday in May
Flag Day, June 14th

The problem with pictorial observances of patriotic holidays is that it is extremely difficult to successfully separate, in a child's mind, the difference between a memorial observance for those who died so that others might live, from a mindless and irreverent portrayal of military mayhem, violence, and gore. Although this preoccupation with the macacbre is limited almost entirely to boys, enough is enough.

To solve this problem I often turn to lessons that center around flags, flowers, or good ol' Uncle Sam!

Lesson #18 An Uncle Sam Hat

While instructions for stovepipe hats are not hard to find, few kids have ever made a genuine "Uncle Sam Hat!"

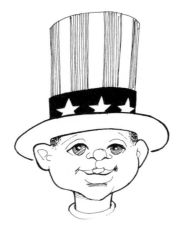

YOU NEED:

 construction paper:

 9 × 24″ or 9 × 18″ and 9 × 9″ white

 4 × 24″ or 4 × 18″ and 4 × 9″ blue

 2 × 9″ strips, red

 12″ square, white

 3″ squares, white

3½" circle pattern (watercup size)

12" (Shy) circle pattern

large stapler

paste, pencil and scissors

TO PRESENT:

1. If the 24" lengths of paper are not available, have your kids paste the 9×18" to the 9×9" lengths, and the 4×18" to the 4×9" lengths to make two long sheets.

2. The red strips are pasted to the long white sheet to make the red and white, flag-like pattern that will decorate the main body of the hat. (See Figure 4–51.)

4–51

3. The circle patterns are used to make concentric circles on the 12" square of white paper. (See Figure 4–52.) Have your kids cut out the large circle and cut away the inside circle, so that a large, donut-like shape remains. Radial segment lines are then drawn, to reach approximately 2" from the outside edge as shown in Figure 4–53. Cut along these lines.

4. The red and white striped paper is then individually fitted to the wearer's head and stapled to size. The donut-shaped hat brim is then lowered over the stovepipe and stapled in half a dozen places. (See Figure 4–54.)

5. White stars are then drawn on the 3" squares of white paper, cut out, and pasted onto the blue hatband, which is, in turn, pasted around the base of the stovepipe hat!

Additional Suggestions: With a little bit of double-stick cellophane tape and a scrap of white paper, an Uncle Sam goatee is yours for the asking!

4–52

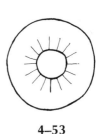

4–53

4–54

A SALUTE TO SUMMER

June 21—September 23

By June 21st, the school year is over (or nearly over), but since summer is more a matter of temperature than one of calendar I see no harm in firing off a couple of summertime salutes during the last few weeks of school!

Lesson #19 Summer Suns

Like adults, kids live in a cliché-ridden world; unless they are bombarded with new ideas, they too can get into ruts. For example, if left to their own devices, 98 percent of all children (the other 2 percent are home sick) will draw a sun that looks like a crown of thorns. Now although this prickly symbol does communicate the message "sun," with constant repetition, this symbol can become as banal as last year's catch phrases. Here then, are a few suggestions for pumping new life into "Ol' Sol"!

YOU NEED:

drawing paper

pencil and crayons

TO PRESENT:

1. Begin by telling your class that they should draw some kind of an outdoor picture, the only restriction being that they are not allowed to draw the sun until you have had an opportunity to discuss this matter with them later in the lesson.

2. When most of your kids are ready to add the sun, it's time for you to perform a "chalktalk." Your routine should run something like this:

(Begin by drawing the standard sun symbol on the chalkboard.) "What's this a picture of? A sun? You're right, that's what people call it. But does it *look* like a sun? A porcupine maybe, a potato speared by toothpicks, possibly, but a *sun*? It doesn't look like that at all!*

"What *does* the sun look like? Like a circle." (At this point, draw a circle on the chalkboard.) "But the trouble here is that this is the same way in which we would draw a full moon. So maybe we shouldn't worry too much about what the sun "looks like" and take time out to explore other ways in which people might draw the sun."

At this point, add the following sun symbols to the chalkboard: the concentric circle sun and the blazing star sun. (See Figures 4–5A and B.)

At the conclusion of your discussion, explain to your kids that, since today is their chance to explore alternate ways of representing the sun, they will have to forget about their tooth-picked-potato-sun and choose one of the above.

4–55A

4–55B

*Once in a while, a bright child will point out that, under certain atmospheric conditions, rays of light will shine down through the clouds in such a way as to look like radiating lines. The answer: "You're right, there are exceptions to every rule!"

Additional Suggestions: While Figures 4–56A and B give the basic idea, some of your most successful pictures will be those done by kids who have colored in the various "compartments" in a decorative manner. (See Figures 4–57.)

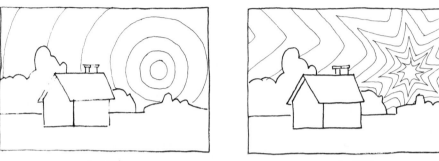

4–56A 4–56B

4–57

FOR MOTHERS AND FATHERS

If there is any group that deserves all the praise we can give, it is our mothers and fathers; for, as we grow older, too many of us discover that we are guilty of giving too little, too late. Here, then, are two lessons to help you and yours do your share!

MOTHER'S DAY

2nd Sunday in May

Unlike Fathers, Mothers—as a group—are an easy people to please, for they respond to all things bright and beautiful. This being the case, here is my contribution: a lesson that is certain to please everyone—kids and Mothers alike!

Lesson #20 Giant Mothers

Kids like all kinds of art activities, but one guaranteed way to please little children is to present them with something considerably larger than their expectations. "Giant Mothers" is one of these lessons.

YOU NEED:

construction paper:

2¼ × 3", 6 × 9" and 6 × 12" "dress" colors

3 × 9" and (two) 4½ × 6" flesh-colored paper*

4½ × 6" white

*See *ART AND KIDS* Glossary.

stapler

paste, pencil, scissors and crayons

TO PRESENT:

1. Begin by having your kids draw a large portrait of their mother's head and neck on one of the $4\frac{1}{2} \times 6''$ flesh-colored papers, and then cut it out with scissors. Put paste on the front of the neck, and paste the neck to the $6 \times 12''$ dress paper.

2. The $6 \times 9''$ dress paper is folded lengthwise and cut along this fold. These pieces become the sleeves to the dress.

3. The long flesh-colored paper is also folded in half and cut on the fold; these two pieces become the legs. The remaining flesh-colored paper is folded widthwise and cut on the fold to provide the material for the hands.

4. The remaining "dress-colored" piece is also folded in half widthwise and cut on the fold. These two pieces provide the material for the shoes.

5. The only remaining paper, the white piece, is folded in half to become the makings for a miniature Mother's Day card, which can then be decorated as the children desire and placed in Mother's hand!

FATHER'S DAY

3rd Sunday in June

Rabbits like carrots,
Horses like hay.
But what about Pop
On Father's Day?

Throw-Away Doggerel

For Easter cards, you can use brightly colored eggs. For Mother's Day cards, you can use bouquets of flowers. But what can you use for a Father's Day theme? A tax form?

The trouble with Father's Day is that it is still a day that needs some sort of satisfactory symbol. For this reason, *good* Father's Day lessons are hard to come by. Here is one of my favorites!

Lesson #21 "Pop" Art

Portraiture is always popular, especially when the subject is an adult and the artist is a child.

YOU NEED:

 7 × 10″ and 12 × 18″ white drawing paper

 8 × 11″ assorted mounting paper

 paste, pencil, scissors and crayons

TO PRESENT:

 1. Explain to your kids that they are going to make a Father's Day card to give to their father, or to any other "big man in their life."*

 2. Pass out the small white drawing paper and ask your kids to draw a large portrait-like head that resembles this "big man" in their life. (Explain that the neck and clothing will come later.)

 3. When it comes to the neck, have your kids feel the width of their own neck and compare this to the width of their

*In this age of casual liaisons, transitory sleepovers, and disposable vows, one has to tread carefully in all matters relating to love and marriage. However, in this case, a reference to grandfathers, uncles, etc., should not be out of place.

head. Necks are almost as wide as heads! (See Figures 4–58 A and B.)

4. Kids usually have a great deal of difficulty arriving at a successful scheme for drawing collars. Here is one way to help them over this hurdle:

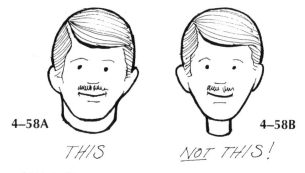

4–58A **4–58B**

THIS *NOT THIS!*

M and W Collars

How to Make the "W Collar": This is the easier of the two; simply draw a W at the bottom of the neck, and follow the steps shown in Figures 4–59A, B and C. Add a shoulder line and a tie, too (if desired).

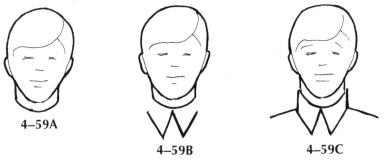

4–59A **4–59B** **4–59C**

How to Make an "M Collar": When making the M or open collar, have the sides of the M extend beyond the sides of the neck. Add collar support lines, a shoulder line, and finish! (See Figures 4–60A, B and C.)

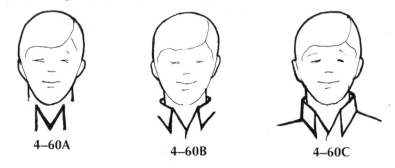

4–60A **4–60B** **4–60C**

5. When the portrait is done, have your kids mount their portraits on the colored mounting paper which, in turn, is mounted on the front of the folded $12 \times 18''$ white paper, to make a large and attractive card. When this is done, *your* job is over. The kids will have their own ideas for the inside of the card!

and

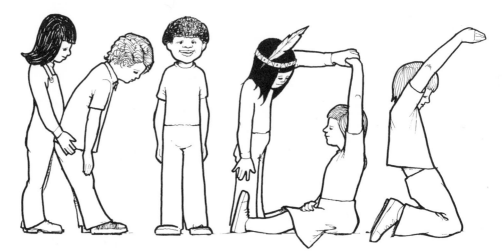

5

Lettering and Kids

Like sports, politics, and religion, all responsible alphabets have a well-defined sense of structure. Not only do the laws governing alphabets insist that an "A" must look like an "A," but also that this "A" must also bear a close resemblance to the rest of the family font. So while many art activities can be as free and boundless as one's imagination, lettering—while often extremely innovative—is nevertheless a game played by the inescapable rules of tradition. But rules need not be stodgy, and rule-learning can be fun. And *that,* of course, is what this chapter is about to prove!

Lesson #1 Alphabet Soup

Most kids (and most adults as well) have, at best, a fairly shaky recall as to the construction of the characters making up the English alphabet. Read them, yes; write them, no! Although we live in a literate culture, in which we are constantly bombarded with the printed word, most of us are always mixing lower case letters with upper case, upper case with lower case, and inventing monstrous hybrids where hybrids do not belong.

The easiest place to begin unscrambling your classroom alphabet is with the basic stick letters, so read on!

LEARNING THE STICK ALPHABET

YOU NEED:

lined paper

pencil or pen

The Basic Upper Case Alphabet

1. To conduct this part of my visual literacy test, assign your kids the task of lettering the upper case alphabet on lined paper. Make each letter two spaces high.

2. While your class is hard at work, *your* job is to draw horizontal guidelines on your chalkboard in preparation for Step 3.

3. Once your kids have done their best, reproduce the following alphabet on the chalkboard. (See Figure 5–1.) Then, have them score their own papers.

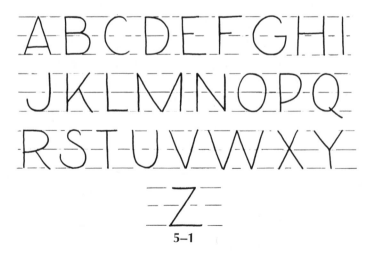

5–1

4. If your students are anywhere near average in their performance, most should do fairly well on this half of the test. Notable exceptions will undoubtedly include the ubiquitous troublemakers, "I" and "J."

I and J: Explain to your kids that nearly everyone in this world (except professional letterers, and possibly typographers) draws their freehand "I" like an up-ended "H." The reason we do so is not difficult to discover; it's the way we were taught!

That the bastardization of the "I" is a necessary pedagogical evil at the primary level is evident to anyone who has ever tried to teach little children the alphabet. How do you teach a little kid the difference between an upper case "I" and a lower case "I" where there is, in fact, no difference at all in the formation of these two letters. Or, to put it another way, here is an actual newspaper heading that I remember reading some years ago. Ask your kids to read this one! (See Figure 5–2.)

5–2

What does it say? Was Richard Nixon being crowned king or was he sick in bed? In the lead paragraph, it soon became perfectly clear that Nixon was confined to his home with a cold Why then the "III"? Given the common newspaper practice of capitalizing all major words in a heading, the result, in this case, was nothing more mysterious than a capital "I," followed by two lower case "I's." The three letters are identical in appearance, and there is nothing we can do about it. Unless of course, we are primary teachers, and then we change the "I" to "i" for the sake of clarity and convenience. (And as an art teacher, it's *my* job to unteach it!)

At this point, the word *serif** will go a long way towards bringing a little clarity into this whole area of confusion. A *serif*, as you probably already know, is that little terminal spur that is used to decorate certain styles of ornate alphabets. (See Figure 5–3.)

5–3

*For a complete lesson on serifs, see page 173.

JIM

JIM

5–4

5–5

In correct practice, either one letters *JIM* or *JIM*. (See Figure 5–4.) Either is right, but the individual letters that make up the two words are not interchangeable. The first is decorated with serifs, the second is *sans serif*.

And as to why most people continue to include a serifed "J" in a sans serif alphabet, the culprit again is the educational system that, in yesteryear, preferred to teach it that way. Some systems still do!

But the misplaced serifs on the "I" and "J" are only the beginning of a long list of common lettering errors. The real zoo begins the moment we take a half-way critical look at the variety of shaggy creatures that commonly inhabit the lower case alphabet.

The Basic Lower Case Alphabet

1. To conduct the second half of this literacy test, ask your kids to letter the lower case alphabet. While the main body of the letters and most ascenders are to be drawn one space high, have your kids draw the descenders just a little short of the guidelines. (See Figure 5–5.)

2. While your class is hard at work, *your* job is to draw more horizontal guidelines on the board in preparation for Step 3.

3. Once your class has had ample time to do their best, reproduce the following alphabet on the chalkboard. (See Figure 5–6.)

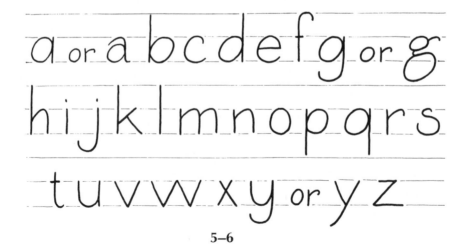

5–6

4. If your class puts in an average performance, the results will probably range from fair to poor, for this is the half of the alphabet that gives everyone the most headaches. The truth is that most people cannot stumble through this exercise without using a mixed bag of serifs and san serif alphabets, containing everything from upper and lower case lettering to monstrous mutations, and even some lame substitutions borrowed from the cursive scripts. Since the mistakes that will be made here are too obvious and too numerous to even try to catalog, let me just say that *after* your kids begin to master the san serif alphabet, the following *minor* suggestions should prove helpful:

5–6A

Correct usage generally calls for one or the other. Do not mix!

Full-Bodied Circles: When making "a's," "b's," "d's," etc, use complete circles.

This:

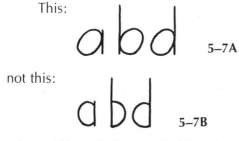

5–7A

not this:

5–7B

"k": Although the small "k" and the large "K" bear a superficial resemblance to each other, the two are *not* identical. (See Figure 5–8.)

5–8

"t": This is the one letter that follows its own rule; for it is neither a double-space nor single space letter, but falls somewhere between the two. (See Figure 5–9.)

5–9

So, now that you and your kids know the basic alphabet, the rest is easy!

Lesson #2 The Care and Feeding of Fat Letters

Since the stick letters are made up of single lines, kids find stick letters easy to make but limited in decorative possibilities. Block letters (or "*Fat* Letters," as the kids prefer to call them) are something else again! Here are a few suggestions for introducing this style of lettering to your kids.

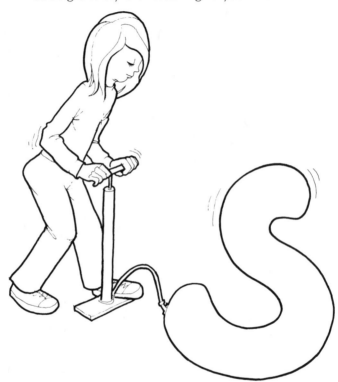

Preliminary Practices: *Making Fat Letters Fat*

While few adults would find the construction of block letters a difficult concept to grasp, a great many kids need help just to get started. Here's how I introduce this alphabet:

YOU NEED:

unlined practice paper

pencil

1. Using a basic stick-figure alphabet, I letter the word "cat" on the chalkboard and ask the kids to do the same on their practice paper. (See Figure 5–10.)

5-10 5-11

5-12

2. "Do it again," I tell them, "But this time *feed* your cat." To show them what I mean, I letter the word as shown in Figure 5–11.

3. By the time the kids finish "feeding" the second cat, I have already started lettering the final cat. (See Figure 5–12.) "Man," I groan, "Is *that* cat *fat*! See if you can make a cat as fat as mine!"

4. With the remainder of their practice paper, I now ask my kids to do their names in "Fat Letters," with a special warning to look out for "road blocks."

5-13A

By using the words "road blocks," I draw their attention to the ways in which some kids "do it wrong." A "T," for example, should look like the "T" in Figure 5–13A, not like the one in Figure 5–13B. Think of each letter as being made up of a paved highway surface, and any lines drawn across this surface as impeding road blocks. (See Figure 5–14.)

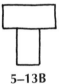

5-13B

Once the concept is understood, the rest is fun!

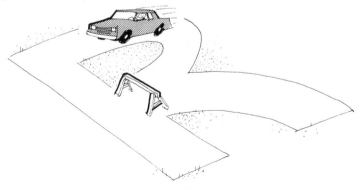

5-14

The Accompanying Activity: *Fat Letters on Parade*

YOU NEED:

9 × 12″ drawing paper
pencil and crayons

TO PRESENT:

After reviewing the introductory lesson above, simply distribute the art supplies and ask your kids to choose a single word (or, possibly, two words) that would look good in decorated block letters. For suggestions, see the variety of approaches illustrated in Figure 5–15.

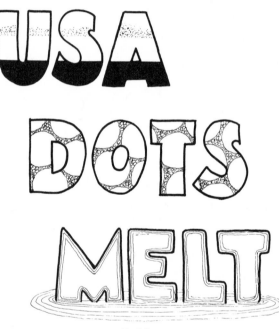

5–15

Lesson #3 Lap Land

There are lots of ways to have fun with the basic block letter: Here are two of my favorites:

The First Lap: *Balloon Lettering*

If you are like most of the teachers I know, you are probably already familiar with what is commonly called "Balloon

Lettering." If you aren't, these characters are easy to learn, for "Balloon Lettering" is nothing more than the "Fat Lettering" of the previous lesson, fashioned with rounded corners!

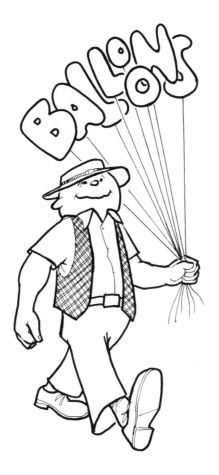

YOU NEED:

 practice paper
 9 × 12″ drawing paper
 pencil and crayons

TO PRESENT:

 1. If your class is already familiar with the "Fat Letters" of the previous lesson, it will take no time at all to retool *this* lesson to accommodate all their needs. (See Figure 5–16.)

5–16

5–17A

2. The difficult part of this lesson will not be the making of the letters, but the overlapping of them. To help my kids wrestle with this concept, I generally begin in the following way:

"This is a square. (See Figure 5–17A.)

"These, of course, are two squares. (See Figure 5–17B.)

"If one of these squares were to step in front of the other, they would then would then look like this. (See Figure 5–17C.)

"Or this, or this. (See Figures 5–17D.)

"And what is true of squares can also be true of letters. (See Figure 5–17E.)

3. Have your kids use their practice paper to try out some simple overlapping. For those children who have exceptional difficulty with this concept, have them draw the letters as if they were transparent, and then erase the lines of the second letter in those places where it overlaps the first. (See Figures 5–18A and B.)

5–17B

5–17C

5–18A

5–17D

5–18B

5–17E

3. Once the concept is mastered, simply invite your kids to use this idea to design one or two large words on the 9 × 12″ drawing paper. The completed work is then colored or decorated to suit individual tastes. No more instruction is necessary!

The Last Lap: *The Suspended Letter*

The effect of this lettering style is that of a paper letter floating a few inches above its own shadow. While this letter style is not always easy for kids to master, the results are well worth the learning!

YOU NEED:

practice paper
drawing paper
pencil and crayons

TO PRESENT:

The "Suspended Letter" is, in theory, as simple as it looks—but don't allow its simplicity to fool you; many kids find it difficult. The only suggestion that I can give you, for those who will experience difficulty with this concept, is that they draw two identical, overlapping letters, and then erase that part of the first letter that is seen "through" the second. (See Figures 5–19A and B.)

5–19A 5–19B

Lesson #4 Depression Moderne

Since I am not a serious student of either lettering or typography, I can't tell you much about the history of this style, except that it was popular during the early thirties. Kids, of course, couldn't care less about the history of lettering or when a particular style was or wasn't in vogue. All they care about

is whether a style is fun to do or whether it isn't. And no al-phabet I know of causes quite the classroom excitement as a child's first introduction to this truly novel alphabet!

YOU NEED:

> practice paper
> drawing paper (or paper bag book covers)
> pencil and crayons

Preliminary Practice

The easiest way to teach this alphabet is to draw it on the board and have your kids copy it on a sheet of unlined prac-tice paper. (See Figure 5–20.)

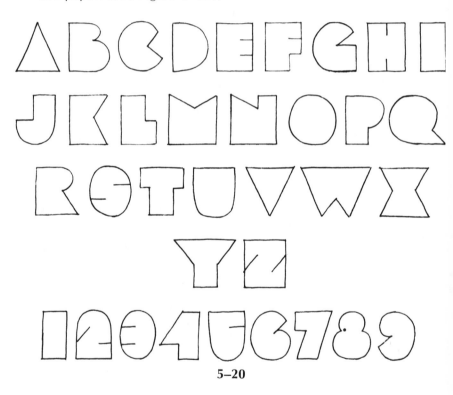

5–20

The Accompanying Activity

Since kids, older kids particularly, are really turned on by this alphabet, almost any assigned lettering activity will be mo-tivation enough. Your kids might want to letter their names, make a "Keep Out" sign for their room, or, if this lesson is pre-

sented early enough in the year, use this lettering style to decorate the paper bag covers of their take-home school books.

Lesson #5 Psychedelic Messages

As "Depression Moderne" is associated with the early thirties, "Psychedelic" lettering was a flower child of the '60s and early '70s. Kids love it!

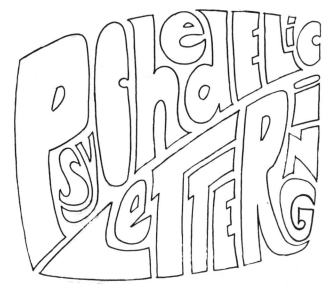

YOU NEED:

practice paper

9 × 12 (or larger) drawing paper

eraser

pencil and crayons

Preliminary Practice

1. I usually begin this lesson by having my kids use their pencils and practice paper to lightly sketch a shape like the one shown in Figure 5–21. Into this shape I have them stuff another one of my "fat cats." (See Figure 5–22.)

2. The rules, as I explain them, are these: all letters must be fat, must (whenever possible) touch the sides of the containing penciled shape, and the spaces between the letters must be little more than narrow rivers of white paper.

And finally, when the word is completed, the containing guideline must be erased. (See Figure 5–23.)

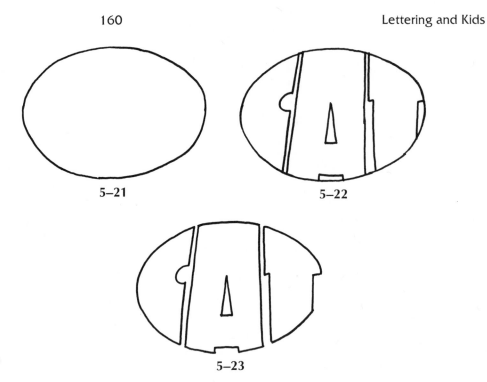

5–21 5–22

5–23

5–24

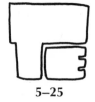

5–25

Special Effects

Since one of the hallmarks of this lettering style is its maximum use of the containing space, the following "tricks" are well worth knowing!

1. An "L" is often best put to use by placing the letter that follows "on its lap." (See Figure 5–24.)

2. "T's" are often best utilized by placing neighboring letters under their "boughs" or "wings." (See Figure 5–25.)

3. Sometimes, when space is at a premium, some of the letters may even be doubled up by placing the preceding letter above the following one, as shown here in Figure 5–26.

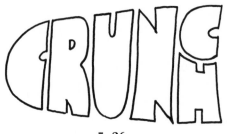

5–26

4. And finally, unlike the "literate" alphabets, "Psyche-delic" lettering is one alphabet that refuses to acknowledge up-per and lower case differences. (See the lead illustration.)

First Activity: *Single Word Psychedelic*

On the 9 x 12" drawing paper, have your kids design and color a single word in the "Psychedelic" style. The confining shapes need not be ovoid, but they should be simple. (See Fig-ures 5–27 A and B)

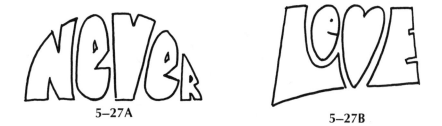

5–27A 5–27B

Some kids are most receptive to the suggestion that they explore the kind of word-shape relationships shown here in Figures 5–28 A,B,C, and D.

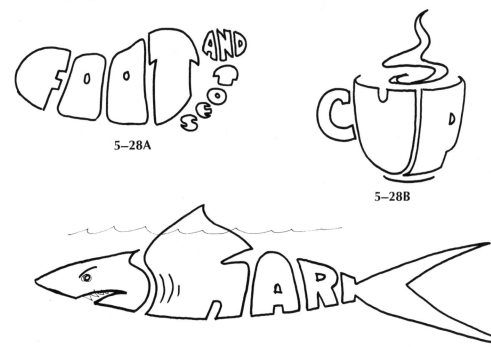

5–28A

5–28B

5–28C

5–28D

Second Activity: *Psychedelic Sentences*

Once the basic "Psychedelic" concept is understood, "Psychedelic" sentences are easy to design and fascinating to contemplate. Begin with containing shapes such as those used for the single-word designs. Using lightly penciled, double dividing lines, separate the containing shapes into as many compartments as needed. (See Figures 5–29 A and B.)

And that's that!

5–29A 5–29B

Accompanying Activities

The only instructions needed here are to "Make it good and make it big," and your kids will be happy to oblige!

Lesson #6 Spaghetti Helpings

As far as kids are concerned, this lesson has *lots* of good things going for it: it is easy to do, it makes for a decorative lettering style, and it's named after one of their favorite foods!

YOU NEED:

practice paper
drawing paper
pencil and crayons

Preliminary Practice

If your kids can write a cursive hand, they can do "Spaghetti" lettering. (See lead illustration.)

The main body of the word is made up of a double line that resembles long strands of spaghetti, while the crossing of the "t's" and the dotting of the "i's" resemble spaghetti pieces.

Accompanying Activity

Once your kids grasp the concept, the fun is motivation enough. Just pass out the drawing paper and let them get to work!

Lesson #7 Entering the Third Dimension

While this lesson is not for the very young, children in Grades 4 through 6 will find this concept as challenging as it

is fascinating. Furthermore, once learned, it provides a stepping stone to all kinds of higher learning!

YOU NEED:

practice paper
drawing paper
pencil and crayons

Preliminary Instructions

I usually try to introduce this concept one small bit at a time. I suggest that you do the same!

1. I begin by drawing a square on the chalkboard and asking kids to do the same on their practice paper. I explain that all one has to do to turn this square into a three-dimensional cube is to follow the simple steps shown here in Figures 5–30 A,B, and C. Try it!

5–30A

5–30B 5–30C

2. Once your kids have had a chance to try out this new concept on their practice paper, you'll find that, while the instructions are relatively clear and concise, the classroom results will invariably include some monstrosities.

3. *Now* is the time to *refine* your instructions. Explain to your kids that there are two rules that *must* be followed here:

(1) all of the uphill (or *oblique*) lines must be drawn at the same angle to the paper, and (2) all must be exactly the same length. If these two rules are followed, the resulting drawing cannot help but be correct.

4. Once the box construction is mastered, have your kids try some of the problems shown in Figures 5–31 A,B and C.

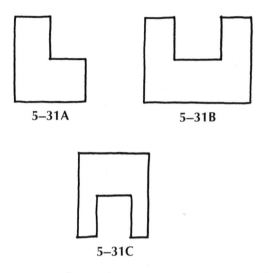

5–31A 5–31B

5–31C

The answers are as shown in Figures 5–32 A, B, and C.

5. If your kids can master the problems presented in Step 4, the alphabet is just as easy. Simply have your class apply this *oblique* construction to a variety of letters until the concept is completely understood. (See Figure 5–33.)*

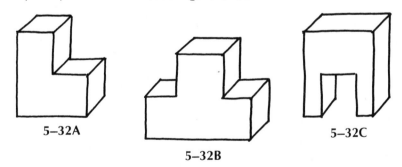

5–32A

5–32B

5–32C

*The understanding of the "O" may need some special attention. At this stage of the learning process, it will be expedient if your kids can just copy your "O," "S," and other complex letters from the chalkboard, until such time as they gain a greater mastery of the process.

5–33

The Accompanying Activity

As in many of the lettering lessons, the body of the work is in learning the concept; once learned, the employment of the idea can take a multitude of forms. Simply pass out the drawing paper and suggest to your kids that they use this three-dimensional lettering style to do their names, a word, a group of words—anything at all that will allow them to put this concept to work!

Lesson #8 Shaded Lettering

Another way of arriving at a three-dimensional effect is to teach your kids how to make "Shaded Lettering." This one's easy!

5–34

YOU NEED:

practice paper
drawing paper
pencil and crayons

Preliminary Practice

"Shaded Lettering" is based upon one or another of the "Fat" alphabets. Two simple rules are all that are needed: add a "shaded" line to all tops and all right-hand sides.* (See Figure 5–34.) Shaded letters are most effective when the shaded line is done in a different color from the one in which the letter has been drawn.

*A perfectly acceptable alternative would be, of course, to shade all tops and *left-hand* sides, etc.

Accompanying Activity

Once the concept has been mastered on practice paper, simply pass out the drawing paper and let your kids put their "Shaded Lettering" to good use!

Lesson #9 Ghost Lettering

Can one have words without letters? You can if you know how to make "Ghost Lettering," for this alphabet is totally bodiless; if it were not for the shadows cast by these letters, you would never be able to read them at all!

HALLOWEEN

YOU NEED:

practice paper
drawing paper
eraser
pencil and crayons

Preliminary Practice

Have your kids lightly pencil in a letter or two in oblique lettering (See "Entering the Third Dimension," p. 163). Shade or color in the thickness to the letters, then erase the remaining outlines. (See Figures 5–35 A and B.)

5–35B

5–35A

Accompanying Activities

Once this concept is understood, have your kids choose an appropriate word or group of words to design in "Ghost Lettering." This lesson is especially popular during the Halloween season. Try it then!

Lesson #10 Towards a Distant Point

After your kids have mastered a "3-D" lettering concept, what could follow more naturally than this simple exercise in *perspective?*

YOU NEED:

practice paper
drawing paper
pencil and crayons

5–36

TO PRESENT:

Explain to your class that this lesson is not unlike the oblique lettering learned earlier (See "Entering the Third Dimension," Page 163), except that the oblique lines here must all be directed towards a single point. (See Figure 5–36.)

As for a final activity, your kids will quickly find a way to put this lesson to good use!

Lesson #11 Double-Pencil Lettering

I have borrowed this lettering style from the commercial artist's bag of tricks and have put it in the classroom where it belongs!

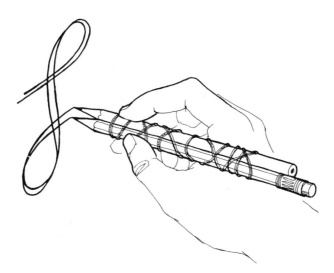

YOU NEED:

 practice paper
 drawing paper
 rubber band
 2 pencils, 2 pens, or one pen and one pencil

Preparation

Before this lesson can begin, the writing instruments (See list of materials above) must be bound tightly together with a rubber band, as shown in the lead illustration.

Preliminary Practice

It takes a little getting used to with this odd, double-pointed writing instrument, for not only must your kids learn to hold it firmly in their hands, but it must be held with the points at an oblique angle to the paper.* (See Figure 5–37.)

*For some kids it is easier to turn the paper than to turn this compound writing instrument at the correct angle. This is particularly true for lefties.

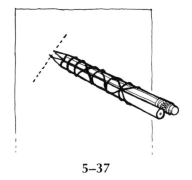

5–37

5–38

The whole secret to this lettering style is to find the proper position for the first letter in a word, and then to "freeze" the hand and the wrist in this position until the last letter in the word has been completed.

The correct position has been arrived at when a top to bottom zigzag looks much like the one shown in Figure 5–38.

For your first letter, start with the lower case "i." The first two strokes should look like those pictured in Figures 5–39A. The finishing strokes are added with *one* of the twin points, as shown in Figure 5–39B.

5–39A 5–39B 5–40

Once the "i" is mastered, have your kids try an "x" and a "k." These letters should look something like the ones shown in Figure 5–40. The secret, once again, is this: once the correct angle is found, the hand and the wrist must be "frozen" in this position for all the letters.

Letters like "C," "G," "O," and "S," are composed of the elements shown here in Figures 5–41A, B and C.

While the initial instruction time is not short, neither is it as long as it may appear to be here, for I am used to teaching this whole style and an accompanying lettering activity in a one-period lesson.

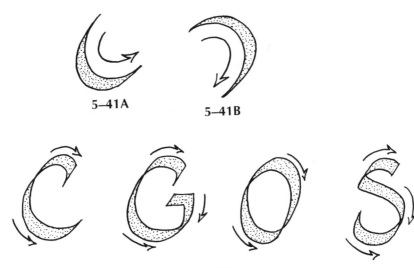

5–41A **5–41B**

5–41C

Accompanying Activities

Once the knack of handling this double-pointed drawing instrument has been mastered, your kids will quickly find a use for it. And once they have demonstrated some familiarity with this instrument as a "printing" tool, encourage them to also use it cursively! (See Figure 5–42.)

5–42

Additional Suggestions

The width of the individual writing instruments that go to make up this "Double-Pencil Lettering" tool will, of course,

decide not only the width of the resulting letters but the size as well. For example take a look at Figure 5–43 to see what happens when our old friend the cat is allowed to shrink!

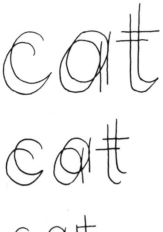

5–43

If a need exists for letters that are either smaller in width or size, simply instruct your kids to jam some kind of a make-shift wedge between the pencils as shown here in Figure 5–44.

As for larger letters (and I have used this principle to lay out large store signs), one need only to separate the points to enlarge the width. In Figure 5–45 the width has been increased by the use of a wedge; in Figure 5–46, it was done by lashing the two writing instruments to a board!

5–44

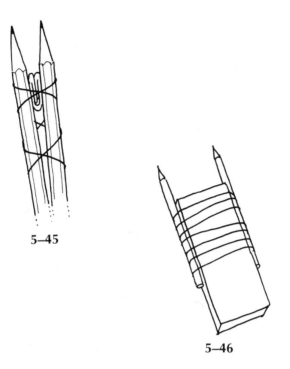

5–45

5–46

Lesson #12 The Misunderstood Serifs

Nothing is more misunderstood than the serifs. They decorate at least half of the alphabets that we see every day, and yet, when called upon to use them, few of us have any idea where they belong! Badly used, they make for pretentious but ignorant airs; well-used, they add a well-mannered touch of sophistication to the written word. Long live the serif!

YOU NEED:

pencil or pen
lined paper

TO PRESENT:

Earlier in this chapter I introduced you to the *serif*. Now, here are the rules of the game!

UPPER CASE SERIFS

The upper case serifs are relatively easy to learn. Here is the basic stick alphabet, dressed in a simple line serif. (See Figure 5–47.)

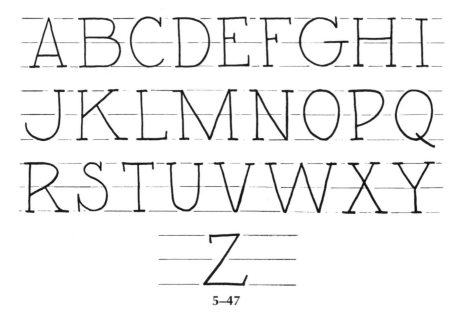

5–47

Note that at no time does a serif extend above or below the guidelines.

This:

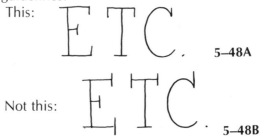

5–48A

Not this:

5–48B

Note also that the C has only one serif, and that one is at the top of the letter.

Otherwise, that's all there is to know about *this* case. (It's the *lower* case that is the more demanding of the two!)

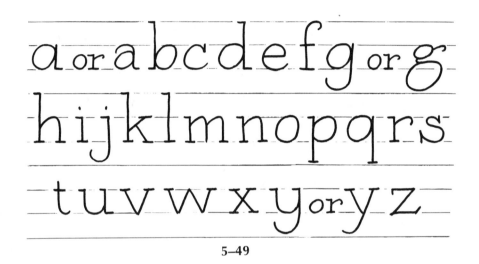

5–49

LOWER CASE SERIFS

The secret to understanding the lower case serif is to be found in what I call "the rule of the l." (See Figure 5–50.) Note that while the "l" has a full serif at the bottom, it has only a half serif at the top, and this half serif points to the left.

The rule of the "l" can be applied to most of the lower case alphabet, either in its "pure" form as seen in the "l," or in an abbreviated way as seen in the "a," "b," "d," "f," "j," etc. (See Figure 5–51.)

5–50

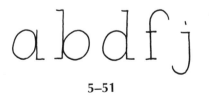

5–51

The way in which the rule of the "l" is modified is this: eliminate that part of the "l" rule that would add confusion rather than dignity to the letter in question. (See Figure 5–52.)

α NOT α

5–52

Generally speaking, those letters to which the rule of the "l" does not apply are those letters that remain unchanged from the upper case. (See Figure 5–53.)

The only lower case letter that follows its own rule is the "k." Note the full serif top and bottom on the right hand side. (See Figure 5–54.)

Note that the first "y" follows the rule of the similiarly shaped "u," while the alternate "y" follows the rule of the "v." (See Figure 5–55.)

V W X Z

5–53

5–54

5–55

5–56

Additional Suggestions

Once your kids have had a chance to experiment with serifs on stick letters, they may welcome your suggestion to explore the idea of adding serifs to the so-called "Fat" letters.

Here, for example, is a fat cat all dressed up in his Sunday serifs! (See Figure 5–56.)

Lesson #13 The Secret of the Thick and Thins

While few elementary classrooms ever seem to find time to explore the "thick and thins" of the stately Roman alphabet,

I have included it here so that you will have not only the secret of the noble Roman, but a reference sheet as well.

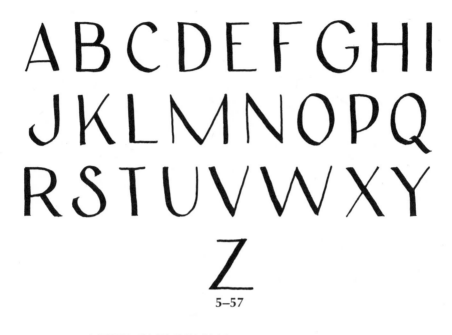

5–57

UPPER CASE ROMAN

Here are a few simple rules:

The rule of the A. The "A," with its heavy downstroke to the right and the narrow downstroke to the left, sets the standard for that part of the letters shown in black in Figure 5–58.

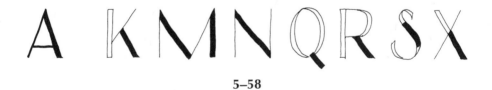

5–58

The rule of the Inverted "A." Turn the above rule upside down and that takes care of all the letters shown in Figure 5–59.

The *Tilted "A"* explains the "Z." (See Figure 5–60.)

The rule of the "E." The "E," with its heavy vertical and its thin horizontals, determines the rule for most of the block-like letters. (See Figure 5–61.)

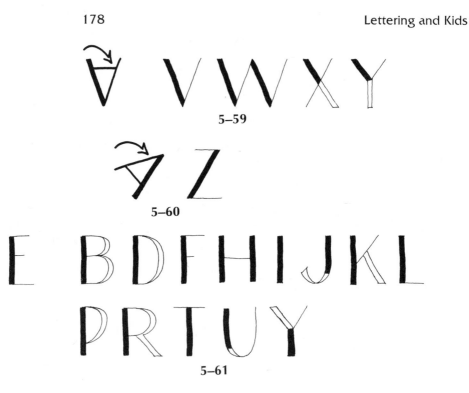

5–59

5–60

5–61

The rule of the "O." The off-centered thin parts of the "O" set the rule for all letters that incorporate curved elements. (See Figure 5–62.)

5–62

LOWER CASE ROMAN

For the most part, the lower case Roman follows the same rules as the upper case.

The rule of the capital "A" still holds true for those letters shown in Figure 5–64.

The heavy verticals and the thin horizontals of the capital "E" continue to apply to this lower case alphabet as well.

The rule of the "O" applies equally to all the curved elements.

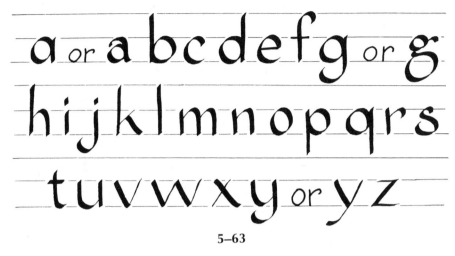

5–63

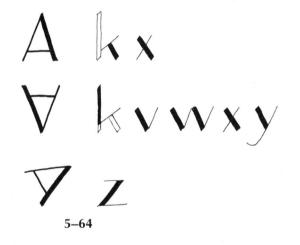

5–64

Additional Suggestions

To see the Roman at its best, you have to see it all dressed in serifs! (See Figure 5–65.)

Roman

5–65

6

Art for the More
Ambitious

No one has ever successfully drawn a positive correlation between neatness and art; in fact, most highly creative people have a much higher tolerance for clutter and apparent confusion than the rest of us. So, while I am not about to sell you on the merits of messes, consider this an advanced warning: while this chapter contains some of the best and most exciting material in this book, the unrelenting price is still a *certain* amount of mess!

INTRODUCTORY LESSON: ART AND CLASSROOM SURVIVAL SKILLS

While mess is often unavoidable, it can be *minimized*! Here are a handful of well-tested suggestions that have served me well; I hope that you find them to be of equal value.

1. *Clean-Up Time.* Always allow plenty of time for clean-up. Better a "wasted" minute or two at the end of a lesson than a slapdash clean-up done at a frantic pace!

2. *Newspapers and Work Boxes.* When the mess is predictable, take appropriate precautions. If you are using paint, etc., cover the desks with newspapers; if the mess is going to

be dry (as in carving or glitter projects, etc.) have your kids try to contain their mess in a *"work box."* The "Sixteen-Part Box"* often makes an ideal and easily-disposed-of paper box. For more durable work boxes, any cardboard container will do.

3. *Powdered Cleansers.* Avoid using powdered cleansers on desks whenever it can be avoided. While these cleansers often do a great job initially, they are inclined to leave behind a white residue that appears *after* the desks are dry. Since this white residue is often as much of a nuisance as the mess it replaces, I would suggest that you do most of your cleaning with plain water, for, in most cases, water works as well as anything. Try it!

4. *Work Storage.* Have enough foresight to plan ahead for the storage of the finished or half-finished art work. Shelves, if needed, can be quickly and easily assembled from boards and some kind of divider-supports (bricks, books, #10 cans, etc.). Old window screens have all the makings for great drying and stacking racks for flat work. Pictures (providing they are not dripping wet) can also be hung from clothespins on lines strung across the room.

5. *Brushes.* It is far easier and much more efficient to have the brushes washed by one person (*you,* or somebody else you can trust to do a good job) rather than to encourage the kind of confusion that results when you direct a whole classroom of kids to the sink (or to the brush buckets) to wash their own!

6. *Watercups.* Unless you look forward to turning your room into a swamp, never allow a watercup to be filled more than half way.

7. *Containers for Pouring Water.* While there are many kinds of containers you can buy that will do the job, none are as inexpensive as the ones you can make from cans salvaged from home or from the school cafeteria. (See Figure 6–1.) To make one of these, all you have to do is form a spout and voila! You have a bright, new, shiny water dispensing can!

*See *ART AND KIDS* GLOSSARY, page 217.

6–1

8. *Tempera: dry or pre-mixed?* Dry tempera has an indefinite shelf life; pre-mixed tempera has a limited shelf life. Dry tempera is never as creamy as the premixed but it is cheaper. The choice is yours!

9. *Serving Tempera.* While you can buy nice, little, shiny, plastic paint trays that are designed for holding individual servings of tempera, the convenience carries a price: these trays must be washed after every use. My suggestion here is to serve your paint on pieces of cheap manila drawing paper. This way you always have "disposable" palettes on hand!

10. *Brush Storage.* While you can buy all kinds of fancy racks and containers to hold brushes, I heartily recommend the following:

 Tin Can Storage. An empty tin can makes as good a storage container as any.

 Inverted Box Container. My favorite brush container is nothing more than an inverted cardboard box perforated with brush-size holes! (See Figure 6–2.)

11. *Watercolors.* I know from long experience that some classroom teachers are unaware that they can purchase individual replacement colors for their classroom watercolor sets. Pass the word!

12. *Lettering Pen Points.* I never allow my kids to "clean" lettering pens, for far more of my pens have been ruined by zeal and good intentions than have ever been lost to rust or corrosion!

6–2

13. *Glue.* If there is any other item in the average school that is more misused than the white glue bottle, I am sure I don't know what it is. The nozzle on these bottles have been designed by geniuses for maximum efficiency, yet everywhere I look, I see them being misused and mutilated. Here are the rules for making sure your glue nozzles will always work: (1) always close the top of the bottle when the glue is not in use, and (2), before using, peal off or flick off (or even *bite* off) the nearly invisible seal of dried glue that often covers the opening.

Never use a scissor blade or any other sharp instrument to ream out the opening of the nozzle. If the glue bottle has been misused for too long a time, and after following the instructions above the glue does not come out, remove the nozzle and thoroughly clean out the two-part nozzle assembly. Reassemble, and use according to the instructions.

14. *Mounting Glued Items.* Glued items dry best under some kind of applied pressure, but since pressure is inclined to force glue out beyond the edges of the glued item, one must be careful not to apply too much glue. When I apply glue to items to be mounted, I generally apply the glue some distance from the edge to be adhered, and then spread the glue on the remaining area with a fingertip. Since glue will not stick to shiny plastic, I then cover the item with a sheet of lightweight

plastic before placing a weight on top. (I save the plastic package wrappings in which some of my art supplies are sold, just for this purpose.) The plastic, of course, can be used over and over again. In lieu of plastic, try waxed paper, etc.

15. *Crayon Sharpeners.* Since sooner or later, someone in your class is going to clog up your pencil sharpener by using it to sharpen a crayon, keep a couple of cheap, pencil-box style pencil sharpeners on hand for lessons in which a sharp crayon is needed.

16. *Pencil Sharpeners.* When your pencil sharpener "wears out," don't waste your money on another if all it needs is a new cutter assembly. (Consult your building custodian, stationery store, or school-supply catalog.)

17. *Paper Cutters.* Most classroom paper cutters could stand sharpening. Have it done today!

18. *Scissors.* With scissors, as with most everything else, you normally get what you pay for. However, if you have bought a batch of cheap scissors and find that they are a little "stiff," a small amount of outward pressure applied to each of the blades will make them function much more efficiently.

KIDS AND WATERCOLORS

A good watercolor is not easy to do, for this medium has a natural inclination to anxiously spread, sprawl, and disastrously run together in all kinds of unpredictable ways; and the colors, that look so beautiful when wet, commonly dry to faded shades of blah. On the other hand, there is nothing quite so sensuously beautiful and lyrically enchanting as a well-executed watercolor. So what's a poor teacher to do? The answer is (of course) to read on! For in the pages that follow, I have assembled an assortment of well-planned *classroom* watercolor lessons in which your success with this medium is virtually assured!

Watercolor Lesson #1 Free and Easy Watercolors

This is one of my favorite lessons. It is easy to present, easy to do, and the results are always fascinating. Try it!

YOU NEED:

watercolors, etc. For this lesson, I much prefer the four-color set (yellow, red, blue, and black), but any set will do.

12 × 18" white drawing paper

sponge (preferably large)

black crayon

TO PRESENT:

Part One

1. Have your kids place a drop of water on the red, yellow, and blue watercolor paints while you take time to explain to your class that: (1) the results from Part One of this lesson may or may not be up to everyone's expectations as to what a picture should "look like," and (2), that today's lesson is only the first part of a two-part lesson.

2. Using a sponge well-saturated with water, go from desk to desk, wetting down first one and then the other side of the white drawing paper. (I sometimes find that the wet paper lies down better, with fewer wrinkles, if I flip the paper once again so as to rewet the first side.) Always smooth out the wrinkles in the wet paper by lifting it up and sponging from the center out.

3. Then, simply instruct your kids to paint whenever they are ready!

4. The paint, of course, is going to run in all kinds of unplanned and unexpected ways, but if the selection of colors is limited to the primaries, the union of spreading wet paint will result in a kind of fluid beauty that cannot be matched by any other medium.

And once the picture has been painted—stop! These pictures should not be overworked; a free and easy painting technique works best here!

5. When the pictures are "done," put them aside to dry.

Part Two

In a day or two (or whenever the pictures are dry), return them to their creators so that your kids can add whatever black crayon finishes are necessary to complete these pictures.

Some of the returned watercolors may actually be near-works of art as is, and can be promptly displayed without further fanfare. Others may need only a few black lines to bring them together. (See Figure 6–3A and B.) Others will be so amorphous in form that they are best used as starters for projection techniques. (See Chapter Two, ADVANCED PROJECTION TECHNIQUES, page 47. One way or another, I *know* that you'll be pleased with the results, so be sure to have plenty of display space reserved for the finished products!

6–3A

6–3B

Watercolor Lesson #2 Pictures of Value

To compare, say, a late 18th century Blake with an early 20th century Sargent or a mid-20th century Picasso is to reflect on the ways in which different ages have sought out distinctly different qualities in their watercolors. While the combination of watercolor and pencil that I am recommending here has

never been extremely popular in any age, this mixed media technique offers all kinds of immediate and tangible classroom rewards.

YOU NEED:

> water colors, etc.
> drawing paper (6 × 9″ or smaller)
> pencil

TO PRESENT:

1. Ask your kids to draw a picture that can be shaded in with pencil.

2. After the picture has been drawn and shaded, have your kids paint directly over their penciled tones!

Additional Comments

Since most kids see colors only in terms of *hues*,* one of the things that this lesson promotes is an understanding of the

*Color is often discussed in terms of its three qualities: *hue, brightness* (or *value*), and *saturation* (or *intensity*). *Hue* is the generic name given to a particular color swatch (for example: red), *brightness* the amount of light or dark that this color swatch contains (is it a dark red or a light red?), while *saturation* refers to the percentage of the hue present. (Two shades of green, for example, can be of the same hue and brightness, but one may be greener than the other!)

ways in which the quality of a color is influenced by the amount of light or darkness that it contains. (The technical term that is sometimes used here is *color value*.)

Your more ambitious students may even want to experiment further with this technique by applying alternating layers of pencil and watercolor.

Watercolor Lesson #3 Sunrise—Sunset

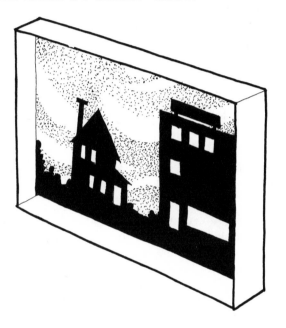

Here is a *very* easy, two-part watercolor lesson!

YOU NEED:

9 × 12″ drawing paper

pencil

12 × 1″ tag board straightedge

paste or stapler

scissors

construction paper:

 7 × 10″ black

 scrap yellow

TO PRESENT:

Part One

1. Have your kids begin by placing a drop or two of water to their yellow, red, and blue watercolor pans so that the paints will be moist and "ready to go" when the actual painting part of this lesson begins.

2. A "Shadowbox Picture Frame"* is then made from the 9 × 12" drawing paper. (This is where the pencil and the straightedge come in!)

3. Once the boxes are made and the watercolors are moist, have your kids paint the inside bottom of their boxes with clear water. After this is done, invite them to use their brushes to dab on small amounts of the three primary colors. The boxes can then be tilted and rotated to allow these primary colors to blend with each other to make an attractive sunrise or sunset! Set aside and allow to dry.

Since this preliminary part of the lesson is not overly long and is fun to do, your kids may want to make two or three of these "sky" pictures in preparation for the concluding half of this lesson.

Storage Suggestions. While wet painting ordinarily takes up an inordinate amount of classroom space, in "Sunrise-Sunset" this problem is greatly reduced through the use of the "Shadowbox Picture Frames" that can be stacked as shown in Figure 6–4.

6–4

*See ART AND KIDS GLOSSARY.

Part Two

1. In a day or two (or whenever the "sky" pictures are dry), return the paintings to their creators. Pass out the black construction paper and invite your kids to draw and cut out a skyline silhouette, then paste this silhouette to the inside of their "Shadowbox Picture Frame."

2. Then paste small, cut-out rectangles of yellow paper onto the silhouette to "turn on" some of the house and building lights! (See the lead illustration.)

ADDITIONAL SUGGESTIONS:

This lesson can be especially attractive if done during the Christmas season. If this is your plan, add a paper punch to your list of needs, so that punched out dots of colored paper can be used to add sprinkles of colored lights to this festive twilight scene.

Watercolor Lesson #4 Watercolored Sprouts

While "blown watercolors" are a fairly common classroom art activity, few kids will ever begin to see the full potential of this technique unless *you* arrange for the learning, and *this* is the lesson that does it!

YOU NEED:

watercolors, etc.

drawing paper

paper or plastic straws

PRELIMINARY PRACTICE:

As commonly presented, a "blown watercolor" lesson is little more than a puddle-blowing activity in which wet watercolor is blown into all kinds of weird, fanciful, accidental creations. The blowing is done either directly with the lips or with straws; both ways are fun. While this puddle-blowing lesson deserves a place in your classroom lesson plans, it is *after* this initial experience that the lesson begins.

TO PRESENT:

1. Have your kids paint liberal puddles of assorted colors along the bottom of a sheet of drawing paper, then have them try to blow the paint towards the opposite end of the paper. (See Figure 6–5.)

2. After the paint has been blown and chased as far as the lungs will permit, have your kids decorate these sprouts with leaves, and possibly even flowers. (See the lead illustration.)

Sensitively done, these pictures make for a beautiful classroom display!

ADDITIONAL SUGGESTIONS:

While the above lesson is by far the most satisfying of all the "Sprout" lessons, here are two other "Sprout" activities that are well worth the mention:

Hair Restoration. Have your kids draw a bald-headed person, paint this head with a liberal amount of wet watercolor, then let them blow it to see how far the "hair" can grow!

Centipedes. Have your kids paint imaginary insects with wet watercolor, then blow to create a multitude of spindly legs.

KIDS AND TEMPERA

Tempera, or poster paint as it is sometimes called, has long been a favorite classroom medium. It can be applied to

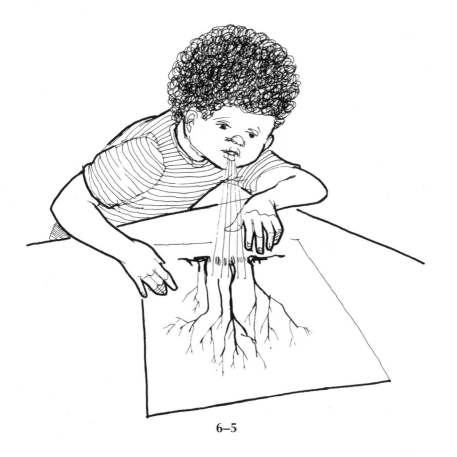

6–5

paper easily, it dries relatively fast, and, since it is opaque, minor corrections are easily made. Many elementary class-rooms have at least one nook or corner of the room set aside for an easel for tempera-painting.

Most lower primary age kids love to paint, and for this reason I see no real purpose in giving them formal "lessons" in painting until they reach the age where they begin to tire of doing the same kinds of pictures over and over again. When this stage of their growth has been reached, here are a handful of lessons that will present your kids with new and exciting challenges.

Tempera Lesson #1 Understanding Color

In our effort to give our children the best of all possible worlds, we are sometimes accused of giving them too much too soon. I sometimes think that this is particularly true of kids

and color. Color comes in thousands of easily discernible nuances, and yet, to hear kids talk, there are only a handful of known colors:

"What color should I paint this?"

"I have already used up all my colors!"

"Aren't there any other colors that I can use?"

This tempera lesson, as well as many that are to follow, is designed to bring the child back to a basic confrontation with the fundamentals of color mixing.

Preliminary Instructions: *The Interlocking Magic Triangles*

Color mixing is a difficult concept for kids to master. While the traditional way to teach this lesson is through the use of a "Color Circle," it is easier and far more interesting to teach color using an interlocking triangle presentation.

1. Have your kids draw a triangle as shown in Figure 6–6, and label the three corners with the three primary colors.

2. The second triangle hosts the secondary colors, and overlaps the first triangle in the manner of the well-known Star of David. (See Figure 6–7.)

6–6

(Those who wish to continue using the more traditional "Color Circle" can arrive at the same relative layout by drawing a circle and placing the primary color circle at 8, 12, and 4 o'clock; with the secondaries at 10, 2, and 6. See Figure 6–8.)

ORANGE — GREEN

VIOLET

6–7

6–8

COLOR MAGIC

You Need:

 tempera, brushes, etc.
 12 × 18″ drawing paper

TO PRESENT:

1. As you are arranging for a distribution of materials, explain to your class that a lot of people go through life without ever understanding how to mix colors. Then explain to your kids that today they are going to have to mix *all* of their colors, except the three primaries (red, yellow, and blue), black, and white. (Technically, black and white are not colors at all, but you'll save yourself a lot of trouble by putting this discussion aside for another time!)

Once your kids have all the necessary materials in front of them, simply invite them to paint anything their hearts desire—there's learning enough in this lesson to keep their interest engaged for a prolonged period of time!

2. Of course, sooner or later, somebody is going to ask, "How do you make brown?" The answer? Mix together any two colors occupying opposite positions on the color star: orange and blue, red and green, or yellow and violet. (See Figure 6–9.)

The "brown" to which most kids respond is the brown that is made by mixing orange and blue. But regardless of the brown they choose, the more perceptive kids will soon begin to arrive at another conclusion: since blue is a primary color, and since orange is a mixture of red and yellow, which are also primary colors, then it follows that a brown made from orange and blue (or any other brown, for that matter) is made by mixing the three primaries! Seen from an educational point of view, just arriving at a desired shade of brown can be a complete color course in itself!

Finally, your kids should be encouraged to try mixing many of their colors with white, for this simple additive affects colors dramatically.

6–9

Tempera Lesson #2 From Out of Darkness

Sometimes all it takes to create a new lesson with a whole new set of learning experiences is to take an old lesson and change just one key element!

YOU NEED:

 red, yellow, blue, and white tempera

 brushes, etc.

 black construction paper

TO PRESENT:

 If your kids have already experimented with color mixing, then this lesson is easy to present. All you have to do is to pass out the materials and let your kids go to work!

 Just the change to black construction paper is enough to present your kids with a whole new set of challenges. There is a great deal of difference between paint applied to white paper and paint applied to black. Dark colors, for example, almost literally disappear into the darkness, only to reappear again when they dry. For some reason, kids are more responsive to the kind of color transformations that take place on black paper than when the paint is applied to ordinary white or cream-colored drawing paper.

Tempera Lesson #3 Brushwork Pointillism

 Here is another black paper painting. While this lesson is a spin-off from the previous lesson, the two have entirely different purposes!

YOU NEED:

 red, yellow, blue, and white tempera
 brushes, etc.
 black paper
 flat bristle brushes

TO PRESENT:

Explain to your kids that this is another lesson in which they will have a free choice of subject matter. Using the primary colors plus white, they can paint anything they want, but—they are not allowed to *paint* with the brush! For this lesson, the brush can only be used for *pressing* on the colors.

By so doing, you have set the stage for all kinds of decorative, pointillistic experiments that can open up all kinds of new horizons in art! (See above illustration.)

Tempera Lesson #4 Painting Without Brushes

Painting can be done in all kinds of ways: with brushes, with rollers, with fingers, and—as in the case of this two-part lesson—with sponges!

Basic Lesson: *Sponge Painting*

YOU NEED:

tempera paints
brushes, etc.
drawing paper
sponges

As demonstrated in an earlier painting lesson on "Brush-work Pointillism," just a simple change of tools can effect a

great change in the resulting work. For sponge painting, use ordinary kitchen-type sponges cut up into triangles about the length of your little finger, along with tempera, and a paper palette. (See "Serving Tempera," page 183.)

Very little further instructions are necessary, for the subject matter is left up to your kids and the paint is daubed on in such a way as to leave behind the uneven, repetitively decorative, "foot prints" of the sponge! (See the lead illustration.)

SPONGE TREES

Many lessons are rich in instructional value, and many lessons are fun to do, but this particular lesson is—in addition—one of those super lessons that everyone wants to do *again*!

YOU NEED:

 yellow, green, blue, and black tempera

 brushes, etc.

 cut-up sponges

 9 × 6" drawing paper

TO PRESENT:

1. For a good, serviceable, realistic, basic tree, suggest to your kids that they use a thinned-down mixture of black with an added touch of green. The basic tree, without foliage, can then be painted according to the instructions given earlier in this book, under the heading "Icicle Trees." (See page 128.)

2. Once the basic tree form has been painted, have your kids use their sponges to add on the leaves. (See Figure 6–10.) Use paint sparingly here, for it is the marks left by the texture of the sponge that are important. While most of the tree can be sponge-painted in green, suggest to your kids that they might like to add yellow to the green for those parts of the tree that would be brightened by the sun, and mix blue with green for those parts that would be cast in shade.

3. And that's it! But be sure to have plenty of paper on hand, because this is certain to be as popular a lesson as you have ever taught!

6–10

KIDS AND PRINTMAKING

There is an aura of magic to printmaking, but it is a special kind of magic that demands participation; for here, as in other art learning experiences, the real knowledge comes in the *doing*. For a child, the learning here is considerable and far more complex than most adults realize, because, among other things, the child must learn to recognize those parts of

the image that print, those parts that reverse,* and learn how, through trick, trial, and bold experimentation, the so-called "repeatable image" can become an art form that offers the young artist an almost unlimited horizon of kaleidoscopic nuances and variations.

Preliminary Lesson: **Basic Tools and Materials**

Printing Inks. Professional printmakers use oil-based inks almost exclusively, but since oil, ink, and kids have an evil attraction for each other, I highly recommend that you avoid them completely. What you and your class need is a water-based printing ink. Like oil-based inks, the water-based inks come in tubes, but unlike oil, the water-based inks are relatively easy to use. So by all means use them!

Brayers. Brayer is what printmakers call the roller used to apply an even coating of ink to a printing plate. (See Figure 6–11.) Brayers come in three basic models: the hard rubber brayer, the soft rubber brayer, and the gelatin brayer. The hard rubber brayer is too hard, the gelatin brayer (believe it or not) dissolves in water! Therefore, for all-around classroom use, I would heartily recommend that you invest in several soft rubber brayers. I find the 4″ size ideal.

6–11

*For example: why does the printing plate image reverse at all? And why does it reverse from left to right, rather than from top to bottom? If the image is to include lettering, do you reverse just the individual letters or do you reverse the whole word? Here, as in the rest of the printing process, it is only through direct, hands-on experience that a child can ever hope to understand these and all the other, equally complicated and complex concepts that make the art of printing so much fun!

Inking Plates. To use ink with a brayer, one needs a smooth, flat surface on which to prepare the printing ink. Two common varieties of inking plates are the ceramic inking tile and the plate bench-hook. (See Figures 6–12 A and B.) While the ceramic tile has the distinct advantage of being forever rust-free, it is also easily broken. The plate bench-hook, on the other hand, is nearly indestructible except that this kind of inking plate is highly susceptible to rust and other kinds of body-rot.

6–12A

6–12B

Which one do I prefer? I'll go with the plate bench-hook and worry about the disadvantages at some other time!

Printing Paper. For classroom purposes, almost any paper will do. You can use newsprint, duplicating paper, mimeograph paper, drawing paper, construction paper: in fact, anything at all that works.*

Printmaking Lesson #1 Two-Timers

You can talk all you want about potato prints and other time-honored classroom printmaking ideas, but this introductory lesson to the monoprint beats them all!

*Other hard, smooth surfaces such as glass or formica can also be used.

YOU NEED:

 printing inks
 inking plate
 brayer
 (duplicating paper works well here)
 pencil

TO PRESENT:

1. Have your kids "roll up" their inking plate with a *thin* coating of water-based ink. Once this is done, have them lay a sheet of duplicating paper on top of the inked plate, and then invite your kids to use their pencils to draw whatever they wish on the "back" of this paper. Once the picture has been drawn, remove the paper from the inking plate, turn it over, and take a look at the inked picture that has appeared on the "front" side of the paper! (See Figure 6–13.)

2. Once this first print has been pulled, have your kids place another paper over this same inking plate without re-inking it. However, this time, invite your kids to *rub* the surface of this new paper with their hands. The resulting print will be, of course, a negative image of the first! (See Figure 6–14.)

3. Since, from this point on, excitement will run high, the only immediate need for *you* will be to see that there is sufficient drying room for the completed prints!

6–13

6–14

Additional Suggestions: The problems that can arise in the making of these "Two-Timers" are so predictable that they can be quickly eliminated by anyone who makes the effort to anticipate them. The first is the problem of too much ink. (Seldom, if ever, do kids seem to be troubled by too little ink!) If a child has been too generous with the ink, simply lay a piece of scrap paper on the inking surface, press, and remove. Now the amount of ink on the surface should be just about right!

The second kind of problem arises the moment someone decides to use this printing method for writing, because anything written on the backside of the printing surface will appear reversed on the inked side. To correct this problem, I would suggest the following course of action:

Have the child letter whatever he or she wants on a piece of scrap paper, then reverse this paper and hold it up to a window. Now trace the the letters, as seen in reverse, to this back, or unlettered side of the paper. Then use this backward lettering as a model for the printmaking process.

After the printmakers have been at work for some time, you might remind them that these prints need not all be drawn in line; try *shading* as well. (See Figure 6–15.)

And finally, if you have set up a number of "stations," each with a different color of ink, you might encourage two- or three-color prints by having your kids start a print on one plate, then moving to another plate to add another colored part to the same picture, etc.

6–15

Printmaking Lesson #2 Glue Prints

Prints can be made from almost anything. You can ink up a flat fish (like a flounder), ink up a weathered board, the flat side of a sliced cabbage, or, as in the case of this lesson, dried glue trails!

Introductory Remarks: Unless you have access to enough white glue bottles to supply everyone in your room with his or her individual glue dispenser, you will either have to bypass this lesson, or do what I do and make this a side-ring enrichment activity to which each child, in turn, will be invited to participate.

YOU NEED:

 tag board

 peeled crayons

 printing inks, brayers, and inking plates

 assorted printing papers

 white glue in bottles

TO PRESENT:

1. Have your kids draw, in outline form, some kind of a design or picture on the tag board, and when they are through, invite them to try to superimpose upon these lines another "line" of *glue.*

2. Once the drawings have been reinforced with glue lines, set them aside to dry.

3. The finished, dried-glue drawings will differ little from the appearance of the wet-glue drawings, but this is what we have been waiting for:

First Ending. Have your kids place a sheet of paper over their dried-glue trails, and then have them use their peeled crayons to make experimental rubbings.

Second Ending. Have your kids use their water-based inks to make prints by inking up the glue trails, placing a sheet of paper on top, and rubbing!

Either way, the results will be well worth the effort.

Art and Kids' Glossary

While a *glossary* sounds like the kind of a heavy addendum one might expect to find at the back of an unreadable textbook, I think that you will find the *ART AND KIDS'* Glossary to be short, sweet, and definitely to the point. While I could have easily included a definition of each term everytime it appeared throughout this book, to do so would have added unnecessary weight to the text, knowingly inconveniencing those who might already be familiar with these terms.*

Circlecones

YOU NEED:

a paper circle or half-circle

pencil

paste

To Make a Circlecone from a Full Circle

Place a dot in the center of the circle and from it draw a radial line. (See Figure G–1A.) Cut on this line, overlap the cut edges, and paste! (See Figure G–1B.)

*Namely the readers of my previous Parker publication, PASTE, PENCILS, SCISSORS AND CRAYONS, from which much of this glossary has been borrowed!

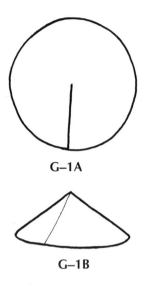

G–1A

G–1B

To Make a Circlecone from a Half-Circle

Divide the baseline in half and pencil a dot at the center point of the baseline. (See Figure G–2A.) Bend as shown in Figure G–2B, and paste!

G–2A

G–2B

End Cones

YOU NEED:

 paper
 pencil
 paste

TO MAKE:

Have your kids a dot halfway between the corners of one of the short edges of the paper. (See Figure G–3A.) Overlap the corners nearest this dot and paste. And that's it! (See Figure G–3B.)

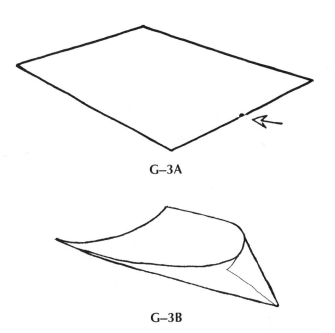

G–3A

G–3B

Flesh-Colored

When a lesson calls for "flesh-colored" paper, I always take time to explain to my kids that, since skin comes in such a wide variety of colors, paper manufacturers do not even attempt to make a "skin-colored" paper.* I explain, therefore, that the best I can do under the circumstances is to rummage through the paper closet to search out those colors that might pass for skin tones. At this point, I select an empty desk or side table to display a selection of papers ranging in hues of peach to dark brown, and then invite the kids, a few at a time, to visit my display to choose a skin color for themselves. In some lessons, I find it instructive to ask each of my kids to place a hand on each of the samples to determine which color most closely

*While this comment may be true today, it wasn't that many years ago when school supply catalogs carried a salmon-colored paper that they sold under the name "flesh."

approximates the color of his or her own skin. (Tan is always a popular color, even with Caucasians!)

As for the peach crayon that is often included in many 12-color crayon sets, I frankly have serious doubts as to the manufacturer's intent in this matter. If peach, why not pear, plum, and pineapple as well? Or is something else intended here? In most elementary classrooms where I find this crayon in use, the kids call it the "skin-colored crayon." While it would be impossible to prove that this is the manufacturer's intent, this popular usage punishes by inference, i.e., a creamy complexion becomes the standard by which all other skin tones should be judged.

As to what crayons should be used to color flesh, I find that almost all skin tones can be easily approximated using a mixture of red and brown crayon. For Caucasians, use a very light red and a very light brown; for most darker skins, use the same colors in greater strengths. For other skin tones, encourage your kids to experiment with the addition of light orange for Orientals, and purple for some of the darkest Blacks.

Sailboat Square

YOU NEED:

a rectangular sheet of paper

TO MAKE:

The "Sailboat Fold" is easier to do than it is to write about. (See Figure G–4.)

The "Sailboat Square" is made by cutting the "boat" from the "sail". (See Figure G–5.) When the sail part is unfolded, it will be a perfect square.

Scoring

YOU NEED:

paper

a pointed instrument such as a pencil, a scissor blade, etc.

TO SCORE:

Paper folds easier if it is pre-grooved along the line on which the paper is to be folded. For this purpose, almost any

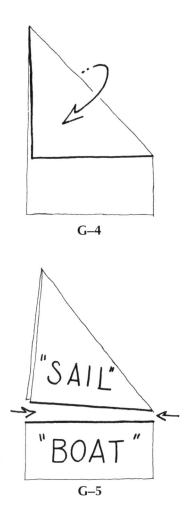

G–4

G–5

pointed instrument will work. (See Figure G–6 illustrating a scissor blade being used for scoring.)

Heavy papers and cardboards are sometimes nearly impossible to fold without scoring. Scoring is seen at its best when used for the kind of curved folds that are shown in Figure G–7.

G–6

G–7

Scribble-Cancelling

When working with large groups of children, it is almost impossible to over-simplify procedural instructions. "Scribble-Cancelling" is one way to simplify lessons in cut-paper where there are either complex figures to be cut out or when the paper pieces have a "right" and "wrong" side.

"Scribble-Cancel" simply means to use a pencil to scribble in those areas that are either to be cut away or turned scribble-side down. A good use of the "Scribble-Cancel" can be seen in each of the following examples:

Example #1: Let us assume that your kids are drawing a large, single-line star. While many children can draw this kind of a star, not all can cut them out successfully. By "Scribble-Cancelling" those areas that are to be cut away, the kids make far less mistakes in the cutting process. (See Figure G–8.)

Example #2: In puzzle-making activities, young children should be encouraged to "Scribble-Cancel" the reverse side of their pictures so that flip-flopped pieces can be immediately identified and corrected. (See Figures G–9A and G–9B.)

G–8

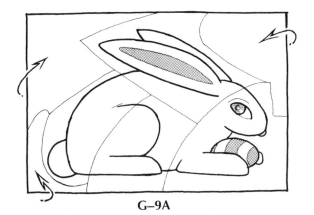

G–9A

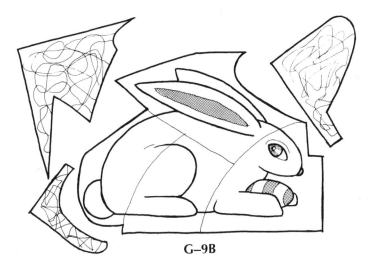

G–9B

Shadowbox Picture Frame

YOU NEED:

paper
pencil
ruler or straightedge
paste

TO PRESENT:

1. Have your kids draw a border around the paper as wide as the ruler or straightedge (See Figure G–10), and press down hard with the pencil at the same time, so that this pencil line will "score"* the paper.

2. Again pressing down hard with the pencil, draw diagonals in all four corners, as shown in Figure G–11. Fold up on all sides and press in the corners as shown in Figure G–12.

3. Fold over the corners and paste. With that, your "Shadowbox Picture Frame" is complete!

G–10

G–11

*See p. 213

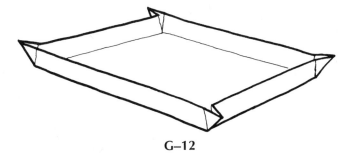

G–12

Sixteen-Part Box

YOU NEED:

> a rectangular sheet of paper
>
> scissors
>
> paste
>
> and perhaps a stapler

TO PRESENT:

1. Have your kids fold their papers in half widthwise, unfold them and then fold the short sides to the middle. (See Figure G–13.)

2. Repeat the same instructions lengthwise and cut on the heavy lines. (See Figure G–14.)

3. The large, center end-flaps are turned up first, then the corner flaps are turned in and pasted. (See Figure G–15.)

4. Finally, have your kids turn down the extending end-flaps and paste. (See Figure G–16.)

G–13

G–14

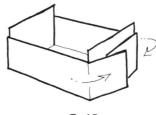

G–15

G–16

Temporary Staples

Many desk staplers are advertised as being able to staple, pin, or tack. Everyone understands what stapling is; a stapler that tacks is one that opens up so that it can be used to staple pictures to a bulletin board (etc.), but what in the world is *pinning*?

A stapler that *pins* is one that is capable of performing two kinds of clinching operations. These staplers can either clinch the wire to look like Figure G–17, or like Figure G–18. When the clinched staple looks like the latter, the stapler is being used in a *pinning* position. The first staple is relatively permanent; the second is a temporary staple that can easily be removed, even by young children.

G–17

G–18

If your stapler pins, its anvil will be designed for both stapling and pinning operations. (The anvil is that part of the stapler indicated in Figure G–19.)

The mechanics of switching from stapling to pinning differs from stapler to stapler. In some staplers, it is done by pushing the anvil back a short distance; in others, the anvil is turned on its axis 180 degrees. Either way, the mechanics of using the stapler remain the same.

ANVIL
G–19

AND FINALLY . . .

If you have enjoyed *IMAGINATIVE ART LESSONS FOR KIDS AND THEIR TEACHERS*, I suggest you pick up a copy of my *PASTE, PENCILS, SCISSORS AND CRAYONS*, for together, these two books are a reference library in themselves. Both are chock-full of creative and valuable art lessons that teach, entertain, and enrich; and, most importantly, they were written for people like *you!*

Index